New Journey

COLLEGE ENGLISH FOR ARTS & HUMANITIES

新征程

艺术类大学英语综合教程 4

总主编 谭 慧 张慧琴
主 编 戴运财 陈 亮
副主编 迟晓宇 卢 茜
编 者 陈维娟 张 颖
　　　 陈艳丽 钟明玲
　　　 武 越

清華大学出版社
北京

内容简介

本套教材共四册，以艺术概论为核心内容进行编排，1-4册分别聚焦艺术的历史（艺术发生论）、艺术的创作（艺术本体论）、艺术与人生（艺术功能论）和艺术与社会（艺术接受论），分别对接通用英语基础和提高、学术英语初阶与中阶能力的培养目标。每册均含8个单元，各册第一单元都为该册核心内容的总体概览，后面7个单元分别围绕美术、音乐、舞蹈、电影、戏剧戏曲、服饰、建筑7大艺术门类的主题依次展开。每个单元的两篇文章分别从中外两个视角呈现其主题内容。本书为第四册。

读者目标：艺术类院校、综合性高校艺术类专业、师范类高校艺体类专业本科生和研究生；艺术英语学习爱好者。

版权所有，侵权必究。举报：010-62782989，beiqinquan@tup.tsinghua.edu.cn。

图书在版编目（CIP）数据

新征程艺术类大学英语综合教程.4／谭慧，张慧琴总主编；戴运财，陈亮主编.—北京：清华大学出版社，2022.12
 ISBN 978-7-302-60849-3

Ⅰ.①新… Ⅱ.①谭… ②张… ③戴… ④陈… Ⅲ.①艺术-英语-高等学校-教材 Ⅳ.①J

中国版本图书馆CIP数据核字（2022）第081466号

策划编辑：刘细珍
责任编辑：刘细珍
封面设计：子 一
责任校对：王凤芝
责任印制：丛怀宇

出版发行：清华大学出版社
 网　　址：http://www.tup.com.cn, http://www.wqbook.com
 地　　址：北京清华大学学研大厦A座　　邮　编：100084
 社 总 机：010-83470000　　邮　购：010-62786544
 投稿与读者服务：010-62776969, c-service@tup.tsinghua.edu.cn
 质 量 反 馈：010-62772015, zhiliang@tup.tsinghua.edu.cn
印 装 者：北京盛通印刷股份有限公司
经　　销：全国新华书店
开　　本：185mm×260mm　　印　张：15.25　　字　数：322千字
版　　次：2022年12月第1版　　印　次：2022年12月第1次印刷
定　　价：79.90元

产品编号：095447-01

"新征程艺术类大学英语综合教程"系列教材

顾问委员会名单

（排名不分先后）

胡智锋
北京电影学院

黄　虎
中国音乐学院

张　尧
中国戏曲学院

姚　争
浙江传媒学院

许　锐
北京舞蹈学院

刘茂平
湖北美术学院

王丽达
中央音乐学院

鲍元恺
天津音乐学院

贺　阳
北京服装学院

沈义贞
南京艺术学院

于建刚
中国戏曲学院

【英】**Ashely Howard**
University for the Creative Arts, UK

【美】**Michael Zhang**
National Cash Register Co., USA

前言

党的十九大报告强调"要全面贯彻党的教育方针，落实立德树人根本任务"。2018年召开的全国教育大会进一步强调"不忘初心""四个回归""培养德、智、体、美、劳全面发展的社会主义建设者和接班人"。《高等学校课程思政建设指导纲要》（2020）明确提出要"抓住教师队伍'主力军'、课程建设'主战场'、课堂教学'主渠道'"；提出就专业教育课程而言，要"根据不同学科专业的特色和优势，深入研究不同专业的育人目标，深度挖掘和提炼专业教育课程知识体系中所蕴含的思想价值和精神内涵，拓展其广度、深度和温度……增加课程的知识性、人文性，提升引领性、时代性和开放性"。为全面落实上述指导意见，依据教育部制定的《大学英语教学指南》中界定的课程培养目标和要求，艺术英语专业分委会集合全国具有代表性的十余所艺术类院校的师资力量，在调查分析大学英语教学现状和预判未来发展趋势的基础上，参考《中国英语能力等级量表》的具体要求，精心策划和组织编写了"新征程艺术类大学英语综合教程"系列教材。

教材以艺术通识知识为纲，以促进中外艺术文化交流为旨，兼顾理论与实践，注重艺术类不同学科之间的交叉互融，既有历史全貌多角度的概览，也有新媒体与新艺术的呈现。

一、教材特色

1. 融入式艺术素养

基于跨学科理念，融多种艺术门类为一体，将艺术的历史、艺术的创作、艺术与人生、艺术与社会、艺术与情感等融会贯通于整套教材中，环环相扣，纵横交错，提升学生的艺术素养，注重学生跨文化交际能力的培养。

2. 浸入式课程思政

所选课文主题强调社会主义核心价值观。在语法、翻译、阅读、写作等练习中均有效融入思政元素，培养学生的创新思维、思辨能力、家国情怀、国际视野，增强学生的文化自信，注重中华艺术文化对外交流和传播能力的提升。

3. 个性化分级教学

依据全国艺术类专业本科生的普遍英语起点水平进行分级编排。在内容层面，1–4册由浅入深分别聚焦不同领域；在语言层面，分级的主要依据是词汇量和课文的Flesch难度。难易梯度的安排贴合艺术类院校学生的实际需求，具有个性化、可选择性的优势。

4. 导向式语言学习策略

教学内容的设计围绕不同艺术类话题与情景而展开，强调"做中学"。同时讲授听说读写译等相应的语言学习策略，在培养学生英语技能的同时，提升其语言综合运用能力和学习能力。

5. 养成式语法写作技能操练

采用"养成习惯的技巧"(habit-forming technique)，帮助学生在循序渐进中学习、操练和习得。融枯燥的语法于多样化的练习中，通过语法点在听、说、读、写、译等不同练习中的复现，使学生有效掌握语法要点和相关句型的交际功能，提升其语言交际能力；融写作技巧于多元的实操内容中，通过艺术批评写作、求职信、数据表格描述、艺术类研究计划等应用文体的反复操练，提高学生的语言实践能力。

6. 预构成语块有效习得

运用语料库，通过真实例句与练习，科学选择并指导学生有效习得预构成语块，避免其孤立硬背生词表，帮助他们培养语感，提升其英语表达的地道性和流利性。

二、教材结构

本系列教材每册设 8 单元,每单元由 Reading A 和 Reading B 及配套练习组成。横向上,1–4 册的选文均以艺术概论的核心内容为准绳,力图使学生掌握艺术领域的通识知识以及艺术英语的常用语汇。纵向上,1–4 册纵向贯穿,由浅入深,分别聚焦艺术的 4 个不同层面。各册第 1 单元选文旨在提纲挈领地介绍该册的核心聚焦领域,后面 7 个单元均按照 7 大艺术门类(美术、音乐、舞蹈、电影、戏剧戏曲、服饰、建筑)依次安排主题,各单元的 Reading A 和 Reading B 则分别围绕该主题从中外两个不同视角进行选材。1–4 册总体安排如下:

册 数	聚焦领域	能力培养
第 1 册	艺术的历史(艺术发生论)	通用英语能力(基础)
第 2 册	艺术的创作(艺术本体论)	通用英语能力(提高)
第 3 册	艺术与人生(艺术功能论)	学术英语能力(初阶)
第 4 册	艺术与社会(艺术接受论)	学术英语能力(高阶)

总之,本系列教材注重跨文化交际能力的培养,融入课程思政元素,彰显艺术类不同学科互通共融之特色。在具体内容的编排上层次清晰,分级科学,基于《中国英语能力等级量表》确定篇章的长度和难易度,循序渐进,符合语言学习的基本规律。同时,充分考虑篇章的思想性、语言规范性、知识性、趣味性、文化性、人文性、时代性、可读性与启发性等;注重题材的多样化,从文学作品到科学小品文,再到经典寓言与名篇演讲,兼顾选材的丰富性和内容价值。旨在丰富和创新艺术类大学英语教学内容,培养通晓中外美术、音乐、舞蹈、电影、服饰、戏剧戏曲和建筑的艺术类国际化特色人才。

由于编写团队水平所囿,书中疏漏在所难免,敬请广大读者批评指正。

<div style="text-align: right">本书编写组</div>

目录

Unit 1 Page 1
Art Criticism and Media Change

Focused Areas of Study
Art criticism and appreciation;

Art change and communication

Viewing/Listening
Listening to a passage: Media companies and TV distributors

Reading

Reading A
What Happened to Art Criticism?

Reading B
After the Media Change

Writing
How to write a film review

Vocabulary
Areas of focus: Art criticism; Media change

Unit 2 Page 27
Personages of Fine Arts

Focused Areas of Study
Appreciation and criticism of famous Western paintings and painters;
Appreciation and criticism of famous Chinese paintings and painters

Viewing/Listening
Watching a video: Andrew Wyeth's inspiration from a farm

Reading

Reading A
Andrew Wyeth: *Christina's World*

Reading B
Chinese Painting at the Turn of the Century

Writing
How to make an email request

Vocabulary
Areas of focus: Painting

Unit 3 — Page 57

Focused Areas of Study
Appreciation and criticism of famous Western musical works; Interpretation of Chinese music and its globalization

Viewing/Listening
Describing pictures: Different musical art forms

Music Appreciation

Reading

Reading A
Tchaikovsky's *Sixth Symphony in B Minor*

Reading B
Contemporary Chinese Music and Its Globalized Present

Writing
How to write an opinion essay

Vocabulary
Areas of focus: Musicological term; Music criticism

Unit 4 — Page 85

Focused Areas of Study
Appreciation and criticism of famous Western ballets; Appreciation and criticism of famous Chinese ballets

Viewing/Listening
Describing pictures: The art form of ballet

The Art of Ballet

Reading

Reading A
Jewels

Reading B
Soaring Wings

Writing
How to write an explanation letter

Vocabulary
Areas of focus: Ballet

Unit 5 — Page 115

Film and Pop Culture

Focused Areas of Study
Appreciation and criticism of famous Western films and pop culture; Interpretation of famous Chinese films and their globalization

Viewing/Listening
Listening to a passage: A biography of Steven Spielberg

Reading

Reading A
Ready Player One
—A Love Letter to Pop Culture

Reading B
Chinese Film in the West

Writing
How to write a report on a research study

Vocabulary
Areas of focus:
Film review;
Film genre

Unit 6 — Page 143

Fushion of the Western and Chinese Theater

Focused Areas of Study
Appreciation and criticism of famous Western theater art works; Interpretation of culture exchange in Chinese theater art

Viewing/Listening
Watching videos:
Eugene O'Neill's play;
Mei Lanfang and Peking Opera

Reading

Reading A
O'Neill and His *Long Day's Journey into Night*

Reading B
Western Flavors in Chinese Theater Art

Writing
How to write case studies

Vocabulary
Areas of focus:
Western and Chinese theater art;
Culture exchange

Unit 7 — Page 173
The Influence of Fashion on Society

Focused Areas of Study
The cultural history of Western fashion;

The spread of Chinese fashion in the West

Viewing/Listening
Listening to a passage: The fashion industry

Reading

Reading A
The T-shirt: A Blank Canvas

Reading B
Overseas Dissemination of Chinese Fashion Styles and Elements

Writing
How to write an essay

Vocabulary
Areas of focus: T-shirts; Fashion dissemination

Unit 8 — Page 201
Architectural Works

Focused Areas of Study
The introduction of a famous Western architect and his works;

Appreciation of modern Chinese architecture

Viewing/Listening
Describing pictures: American architect; Frank Lloyd Wright's main works of design

Reading

Reading A
American Architect Frank Lloyd Wright and His Key Works

Reading B
Modern Chinese Architecture

Writing
How to write a research proposal

Vocabulary
Areas of focus: Architecture design; Architecture feature

Learning Objectives

Students will be able to:

- ✓ Understand the vocabulary of art criticism;
- ✓ Describe the effects on young generations brought by different media;
- ✓ Understand the vocabulary of media change;
- ✓ Write reviews on some works of art.

Unit 1
Art Criticism and Media Change

Lead-In

Task 1 Exploring the Theme

Listen to the passage and answer the questions.

1) What creates new opportunities for media companies to engage audiences?

2) What did the TV distributors use to cut distribution costs?

Task 2 Brainstorming

Answer the following questions. Discuss with your classmates and share your answers with the class.

1) What do you think art criticism is?

2) What are the most influential media in the past ten years?

Task 3 Building Vocabulary

Talk with your classmates, and try to describe the following words and phrases in English.

> exhibition brochure cyberspace literacy cell phone circulation

Reading A

What Happened to Art Criticism?

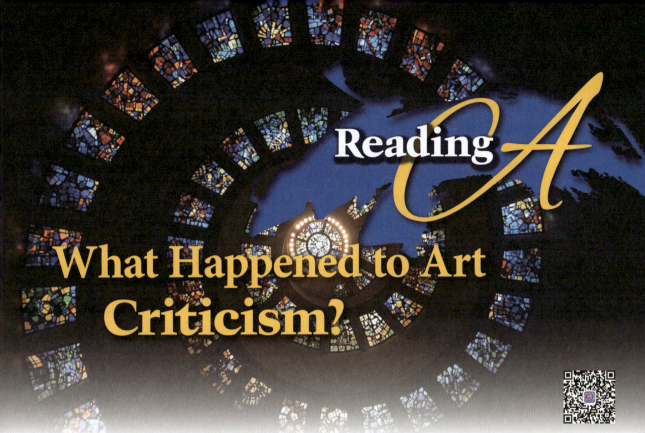

1 Art **criticism** is in worldwide crisis. Its voice has become very weak. At the very same time, art criticism is also healthier than ever. Its business is **booming**: It attracts an enormous number of writers, and often benefits from high-quality color printing and worldwide distribution. In that sense, art criticism is **flourishing**, but invisibly, out of sight of **contemporary** intellectual debates. So, it's dying, but it's everywhere. It's ignored, and yet it has the market behind it.

criticism *n.* 批判；评论

boom *v.* 繁荣；流行

flourish *v.* 繁荣；昌盛

contemporary *adj.* 当代的；现代的

2 There is no way to measure the quantity of contemporary writing on visual art. Art galleries almost always try to produce at least a card for each **exhibition**. If they can print a four-page **brochure**, it will normally include a brief essay on the artist. Galleries also keep files on hand with **clippings** and photocopies from local newspapers and **glossy** art magazines. Gallery owners will gladly copy those pages for anyone who asks.

A world full of pictures

exhibition *n.* 展览；展出

brochure *n.* 手册；小册子

clipping *n.* 剪报

glossy *adj.* 光滑的；有光泽的

3 An afternoon walk in the gallery district of a city can

quickly **yield** a bulky armful of exhibition brochures, each one beautifully printed, and each opening with at least a hundred-word essay. There is also a large and increasing number of glossy art magazines, despite the fact that the market is very **risky** from an entrepreneur's point of view. Large magazine displays in booksellers carry dozens of art magazines. Glossy art magazines can also be found in newsstands near museums and in college bookstores. No one knows how many glossy art magazines there are because most are considered **ephemeral** by libraries and art databases. There are so many that no one I know even attempts to keep track. As a rule, academic art historians do not read any of them. At a rough guess, I would say there are perhaps two hundred nationally and internationally distributed art magazines in Europe and the United States, and **on the order of** five hundred or a thousand smaller magazines and journals. No one knows how many exhibition brochures are produced each year, mainly because no one knows how many galleries there are in the world. Large cities such as New York, Paris, and Berlin have annual gallery guides, but they are not complete and there is no **definitive** listing. As far as I know, no library in the world collects what galleries produced. Daily newspapers are collected by local and national libraries, but newspaper art criticism is not a subject term in any database I know. Therefore, art criticism published in newspapers quickly becomes difficult to **access**.

4 In a sense, then, art criticism is very healthy indeed. So healthy that it is **outstripping** its readers—there is more of it around than anyone can read. Even in midsize cities, art historians can't read everything that appears in newspapers or is printed by museums or galleries. Yet at the same time art criticism is very nearly dead, if health is **measured** by the number of people who take it seriously, or by its interaction

A young man stopping in front of the paintings in the gallery

with neighboring kinds of writing such as art history and art education. Art criticism is massively produced, but massively ignored.

massively *adv.* 大量地

5 Scholars in my own field of art history tend to notice only the kinds of criticism that are heavily historically informed and come out of academic settings. Art historians who specialize in modern and contemporary art also read *Artforum*[1], *ArtNews*[2], *Art in America*[3], and some other journals, but they tend not to cite essays from those sources. Among the peripheral journals is Donald Kuspit's *Art Criticism*[4], which has only a small circulation even though it should in principle be of interest to any art critic. The same can be said of art historian's awareness of newspaper art criticism: It's as a guide there, but never as a source to be cited unless the historian's subject is the history or an artist's reception in the popular press.

specialize *v.* 专门研究；专攻

peripheral *adj.* 外围的；次要的

circulation *n.* 发行量；流通；传播

awareness *n.* 意识；认识

A woman browsing a magazine

6 Do art criticism and catalog essays function primarily to get people into galleries and to induce them to buy? Probably yes. But in the case of catalog essays, the economic effect does not seem to depend on the writing actually being read—often it is enough to have a well-produced brochure or catalogue on hand to convince a customer to buy. It is not entirely clear whether criticism affects the art market except in prominent cases when the buzz surrounding an artist's show can certainly drive up attendance and prices. In my experience, even art critics who work at prominent newspapers receive only a modicum of letters except in unusual cases. The same phenomenon occurs on the Internet, in regard to e-zines: Weeks

convince *v.* 使确信

prominent *adj.* 重要的；著名的

attendance *n.* 出席；到场

modicum *n.* 少量

1 《艺术论坛》杂志。
2 《艺术新闻》杂志。
3 《美国艺术》杂志。
4 《美术批评》，由唐纳德·库斯比特撰写。

and months can pass with no sign that the texts are being read, and those deserts are **punctuated** by flurries of emails on **controversial** issues.

7 So in brief, this is the situation of art criticism: It is practiced more widely than ever before, but almost completely ignored. Its readership is unknown, unmeasured, and disturbingly ephemeral. If I pick up a brochure in a gallery, I may glance at the essay long enough to see some keywords—perhaps the work is said to be "important" "serious", or "Lacanian"[1]—and that may be the end of my interest. If I have a few minutes before my train, I may pause at the newsstand and **leaf through** a glossy art magazine. If I am facing a long plane flight, I may buy a couple of magazines, intending to read them and leave them on the plane. When I am visiting an unfamiliar city, I read the art criticism in the local newspaper. But it is unlikely (unless I am doing research for a project like this one) that I will study any of those texts with care or interest: I won't mark the passages I agree with or **dispute**, and I will not save them for further reference. There just isn't enough meat in them to make a meal: Some are **fluffy**, others **conventional**, or clotted with polysyllabic praise, or confused, or just very, very familiar. Art criticism is **diaphanous**: It's like a **veil**, floating in the breeze of cultural conversations and never quite settling anywhere. The **combination** of vigorous health and **terminal** illness is growing increasingly **strident** with each generation. The number of galleries at the end of the twentieth century was many times what it was at the beginning, and the same can be said of the production of glossy art magazines and exhibition catalogues.

(1065 words)

(Adapted from: Elkins, J. *What Happened to Art Criticism?* Chicago: Prickly Paradigm Press, 2003.)

1 拉康派。

Part I Understanding the Text

Task 1 Global Understanding

1. Write down the key idea of each paragraph below.

Paragraph 1: _____

Paragraph 5: _____

Paragraph 7: _____

2. Read the text and decide whether the following sentences are true (T) or false (F).

() 1) There are some ways to measure the quantity of contemporary writing on visual art.

() 2) There is an increasing number of glossy art magazines.

() 3) According to the author, some libraries in the world collect what galleries produced.

() 4) Art criticism is very healthy in a sense.

() 5) The number of galleries at the end of the twentieth century is the same as what it was at the beginning.

Task 2 Detailed Understanding

1. Read the text again and choose the best answer to each question below.

1) According to the author, glossary art magazines can be found in some places. Which place is NOT mentioned in the passage?

　A. Second-hand bookshop.

　B. Newsstands near museums.

　C. College bookstores.

　D. Magazine displays.

2) Why did the art historians refuse to cite essays from the journals such as *Art in America* although they would read them?

 A. Because they try to save time and energy.

 B. Because they tend to cite the criticism with academic settings.

 C. Because they think these journals are useless.

 D. Because they have to follow the guidance.

3) What does "brochure" mean in Paragraph 2?

 A. A notebook which can be used to take notes.

 B. A magazine which can be bought in the newsstand.

 C. A thin book with pictures that gives you some information.

 D. A textbook which can be used in class.

2. Answer the following questions according to the text.

1) Why is the business of art criticism booming?

2) According to the text, what does the economic effect of catalog essays depend on?

3) How do you understand the sentence "Art criticism is diaphanous." in Paragraph 7?

Part II Building Language

Task 1 Key Terms

The words or phrases below are related to art criticism. Discuss with your classmates and provide your understanding about each term in English.

1) criticism: _____

2) gallery: _____

3) magazine: _____

4) exhibition: _____

5) distribution: _____

6) art: _____

7) clipping: _____

8) brochure: _____

9) photocopy: _____

10) readership: _____

Task 2 Vocabulary

Choose the correct word or phrase from the box below to complete each of the following sentences. Change the form where necessary.

| criticism | combination | awareness | controversial | measure |
| convince | exhibition | flourish | specialize | reception |

1) A dipstick is used to _____ how much oil is left in an engine.

2) I have an appointment with a professor who _____ in the history of Rome.

3) They will be _____ their new design at the trade fairs.

Unit 1 Art Criticism and Media Change

4) You should try to _____ exercise with a healthy diet.

5) A good _____ is important because she is usually the first point of contact for clients.

6) The proposed cuts have caused considerable _____.

7) Everyone should be made _____ of the risks involved.

8) Few businesses are _____ in the present economic climate.

9) The newspaper has been the most consistent _____ of the government.

10) I am _____ that she is innocent.

Part III Translation

1. Translate the following sentences into Chinese.

1) There is no way to measure the quantity of contemporary writing on visual art. Art galleries almost always try to produce at least a card for each exhibition. If they can print a four-page brochure, it will normally include a brief essay on the artist.

2) There is also a large and increasing number of glossy art magazines, despite the fact that the market is very risky from an entrepreneur's point of view.

3) Scholars in my own field of art history tend to notice only the kinds of criticism that are heavily historically informed and come out of academic settings.

4) The same phenomenon occurs on the Internet, in regard to e-zines: Weeks and months can pass with no sign that the texts are being read, and those deserts are punctuated by flurries of emails on controversial issues.

5) The number of galleries at the end of the twentieth century was many times what it was at the beginning, and the same can be said of the production of glossy art magazines and exhibition catalogues.

2. Translate the following sentences into English.

1) 你从这幅画中看到了什么样的线条?

2) 美术评论家与画家的关系要建立在平等的基础上。

3) 画家要用艺术语言记录创作中产生的问题。

4) 在中国古代传统的书画界,评论家本身也是画家。

5) 会画画是否应该成为一个美术评论家必备的条件?

Reading B

After the Media Change

diverse *adj.* 不同的；各式各样的

emergence *n.* 出现；显现

diffusion *n.* 扩散；传播

permit *v.* 许可；准许

1 While there are many **diverse** points of view, historians and sociologists agree that American culture has been shaped by three postwar developments: (1) the Cold War[1] and the United States' **emergence** as the world's superpower; (2) the rise in birth rates following the war that produced a great "baby boom"[2]; (3) the rapid **diffusion** of television and other electronic media in the whole society. To better understand the reasons, let us now take a close look at some of the cultural consequences.

2 Because it did not suffer massive destruction during the war, the United States was well positioned to provide much of what the world needed to rebuild. The result was a wealth-producing economy that **permitted** the rapid expansion of a working middle class. After the Great Depression[3] and wartime

1 "冷战"，1947—1991 年，以美国、北大西洋公约组织为主的资本主义阵营与以苏联、华沙条约组织为主的社会主义阵营之间的政治、经济、军事斗争。
2 婴儿潮时期，指"二战"之后美国新生人口急剧增加的时期。
3 经济大萧条，1929—1933 年发源于美国，后来波及整个资本主义世界。

rationing, the increasing affluence was a welcome change. Rising incomes and government assistance programs made it possible for vast numbers of people to buy new homes and have children. During the Depression and war years, the birth rate in the United States had declined. But once the war ended, couples quickly reversed the trend and created the greatest population explosion in the U.S. history.

The Television Generations

3 Those who were born in that period have the distinction of being members of the first TV generation. During their school years, TV emerged as a new and amazing technological wonder. For the so-called baby boomers, the TV set quickly became their baby-sitter, their teachers and their companion. Where radio had conveyed the sounds of the world to the ears, TV brought the homogenizing images that defined this generation's sense of reality as well as itself.

4 For them, the joy of entertaining oneself was replaced by the joy and expectations of being entertained. A stream of "live" news and entertainment poured into their homes and filled the time that once was used for leisure reading and sharing meals. To provide more time for watching the "tube", cooking gave way to frozen TV dinners. Dining at a table was replaced by eating on folding TV trays. By the time this generation began to have their own children, the medium had penetrated nearly all social and economic strata. It had spread from the living room into dining room, kitchens, bedrooms, and even the bathrooms of some homes.

The Growth of Media Choices

5 For those people who were born since the early 1960s, personal computers and global networks are providing the means to bypass mainstream media. This is a generation for whom mobile and interactive contacts are taken for granted. They didn't rely on television, radio, newspapers, and magazines to define reality for them. Instead, many members of

this generation seem to be determined to create their own more intimate and dynamic realities in cyberspace.

6 In fact, the choices for entertainment were always limited and were always "live". For most time, people entertained themselves or each other. The rapid growth of media choices has altered our expectations. General circulation newspapers first reached more than half the U.S. population in the 1880s. Since then, every generation has been radically transformed by the emergence of at least one new form of mass media in a short period. Instead of discarding the older forms, we have added to them and changed them.

7 Today, people blend many forms of media to suit their needs, and think little of it. For those who commute to work, a typical day might begin with the bedside clock radio for weather and traffic conditions. After that, they would choose a morning television news or talk show while dressing and look through the morning paper for interesting stories at breakfast. On the way to work, they might turn on the radio for more news and traffic updates. Sometimes they tend to listen to their favorite music. At the office, a newsletter might be waiting along with a financial newspaper and a trade magazine. Throughout the day, they exchange bits of information with colleagues and clients by telephone, express mail, memos and perhaps electronic mail. On their way home, they might listen to music so as to reduce their stress. While they are preparing dinner, a cable news program might provide information in the background. After dinner, they might relax with hours of TV, a video game, a magazine or a book. Some might use their personal computers to gather information or join a "chat" section.

Young people entertaining themselves in cyberspace

8 None of this seems strange to us. In spite of the complaints of media overload, our expectations of instantaneous

communication continue to grow.

The Decline of Literacy

9 The assimilation of electronic technologies into everyday lives has had profound social consequences. In the 1890s, a well-educated person living in an English-speaking country was one who could recite from memory several poems by Alfred Tennyson[1]. Most university graduates would also have committed to memorizing a great portion of Western civilization's accumulated knowledge of the sciences and arts.

10 But as radio and TV expanded their hold on people's time, rote memorization gave way to the development of new skills. Students didn't acquire specialized knowledge through intensive reading. Instead, they were expected to gain a general world view through extensive reading. Emphasis also began to shift from critical thinking to quick information processing. Most recent college graduates can no longer recite Tennyson's *Charge of the Light Brigade*[2] from memory. In fact, they have been exposed to more "bits"[3] of information.

Increasing Concerns About the Future

11 The social consequences of these shifts have become the subject of deep concern. Surveys have shown steady declines in reading and writing skills, as well as in basic knowledge of history and science. Some have suggested that literacy may no longer matter. New forms of computer-based visual media would soon relegate written language and print media to an elite form of communication.

12 Many educators and politicians recommended a return to the basics, or the so-called three Rs—reading, writing and

1 阿尔弗雷德·丁尼生 (1809—1892)，英国维多利亚时代最受欢迎且最具特色的诗人。
2 诗歌《轻骑兵的冲锋》，由丁尼生创作。
3 比特，计算机存储的最小信息单位。

arithmetic. Publishers are worrying that no one will be interested in reading their publications in the future. Historians are wondering if the end of history is at hand. All of these concerns indicate the profound transformations which take place in modern civilization.

Smart phone as an indispensable tool nowadays

arithmetic *n.* 算术

Future Media Environments

13 Advertisements for future media technologies push natural as well as printed sources of information into a backseat role. Automotive companies, for example, are now promoting future cars and vans with every imaginable form of electronic communications media built in, from telephones and televisions to global satellite tracking and navigation systems. Commercials for these "media mobiles" often aim at families vacationing in remote, pristine regions. Instead of enjoying the natural splendors that surround them, the children are shown watching TV sets mounted on each seatback. The parents, however, fuss with a navigational display or talk on their cell phones.

imaginable *adj.* 可能的；可想象的

navigation *n.* 导航；航行

pristine *adj.* 没有污染的

splendor *n.* 壮丽

mount *v.* 安装

14 Cyber media have begun transforming the way people define themselves. In cyberspace, individual can be whoever they want to be. They can change personas as easily as changing their clothes. Clearly, reality is no longer as easy to define as it once was. Quite possibly, future generations may come to accept that reality is whatever they want it to be. Through advanced neural network, all of humanity may one day share experiences beyond anything we can comprehend today.

comprehend *v.* 理解；领悟

(1201 words)

(Adapted from: Fidler, R. *Mediamorphosis: Understanding New Media*. London: Pine Forge Press, 1997.)

Part I Understanding the Text

Task 1 Global Understanding

1. Write down the key idea of each paragraph below.

Paragraph 4: _____

Paragraph 7: _____

Paragraph 10: _____

2. Read the text and decide whether the following sentences are true (T) or false (F).

() 1) A wealth-producing economy contributed to the expansion of a working middle class.

() 2) The people who were born in the early 1960s take mobile and interactive contacts seriously.

() 3) Most college students have been exposed to "bits" of information.

() 4) Surveys have shown declines in some basic skills such as reading and writing.

() 5) In cyberspace, individuals can't be free to become who they want to be.

Task 2 Detailed Understanding

1. Read the text again and choose the best answer to each question below.

1) For the so-called baby boomers, which of the following is NOT the role of the TV set?

 A. Teacher.

 B. Boss.

 C. Companion.

 D. Baby-sitter.

2) According to the text, which of the following statement is NOT true?
 A. The rapid growth of media choices has changed our expectations.
 B. College students were expected to gain a general world view through intensive reading.
 C. University graduates used to be able to recite the poems by the famous poets.
 D. Reality is no longer as easy to define as it once was.

3) What does "boom" mean in Paragraph 1?
 A. phenomenon
 B. increase
 C. change
 D. rate

2. Answer the following questions according to the text.

1) What are the three postwar developments that has shaped the American culture?

2) For a commuter, what might a typical day begin with?

3) What are the social consequences of the shift from rote memorization to new skills?

Part II Building Language

Task 1 Key Terms

The words or phrases below are related to media. Discuss with your classmates and provide your understanding about each term in English.

1) media: _____

2) television: _____

3) entertainment: _____

4) computer: _____

5) network: _____

6) interactive: _____

7) radio: _____

8) express mail: _____

9) cyberspace: _____

10) literacy: _____

Task 2 Vocabulary

Choose the correct word or phrase from the box below to complete each of the following sentences. Change the form where necessary.

diverse	emergence	explosion	expect	define
comprehend	circulate	permit	acquire	literacy

1) Research shows that it plays a primary role in language _____.

2) No new evidence _____ during the investigation.

3) Some parents have unrealistic _____ of their children.

4) Let's open the windows and get some _____ in here.

5) There is a need for greater _____ and choice in education.

6) No official _____ has been given for the event to take place.

7) She describes how the _____ of beauty has changed over the years.

8) In the past, a large percentage of the population were _____.

9) The course also features creative writing exercise and listening _____.

10) Bombs were _____ all around the city.

Part III Translation

1. Translate the following sentences into Chinese.

1) While there are many diverse points of view, historians and sociologists agree that American culture has been shaped by three postwar developments.

2) Rising incomes and government assistance programs made it possible for vast numbers of people to buy new homes and have children.

3) Where radio had conveyed the sounds of the world to the ears, TV brought the homogenizing images that defined this generation's sense of reality as well as itself.

4) They didn't rely on television, radio, newspapers, and magazines to define reality for them. Instead, many members of this generation seem to be determined to create their own more intimate and dynamic realities in cyberspace.

5) Commercials for these "media mobiles" often aim at families vacationing in remote, pristine regions. Instead of enjoying the natural splendors that surround them, the children are shown watching TV sets mounted on each seatback.

2. Translate the following sentences into English.

1) 这场演出有很大的娱乐价值。

2) 大众传媒对于体育产业的发展有着极其重要的作用。

3) 她利用网络空间给世界各地的朋友发送信件。

4) 这份文件将在所有成员中传阅。

5) 这将使电子游戏的互动性更胜以往。

Writing Skills

Writing a Film Review

Part I Preparation

Task 1 Introduction

A film review is a work of criticism addressing the merits and defects of a film. Generally, it implies a work of journalistic film criticism rather than academic criticism. Such reviews have appeared in newspapers and printed periodicals since the beginning of the film industry, and now are published on general-interest websites as well as specialized film review sites.

Task 2 Preparation Task

The following sentences are from an example of a film review. Fill in the blanks with appropriate words given in the box.

| audience | depicts | screenplay | true-life | shows | deduce |
| motivations | atmosphere | manner | appears | as though | |

1) *Foxcatcher* is a disturbing film, not only because of the _____ events it _____, though those are certainly unnerving and dismaying.

2) Director Bennett Miller, working from a(n) _____ by E. Max Frye and Dan Futterman, creates a(n) _____ of unhappiness and shame that works as an emotional fog.

3) However, through all the sweat, tears and finally blood that _____ here, we feel _____ we were watching at a remove, an objective _____ to a highly subjective set of situations.

4) We can see and logically _____ what motivates each of the Schultz brothers.

5) The film *Foxcatcher* _____ us what Schultz brothers do, but never weighs in on their precise _____.

6) *Foxcatcher* is suspenseful, though not in the _____ of a normal thriller.

Part II Reading Example

In the film *Kill the Messenger*, written by Peter Landesman (who also has a background as a journalist) and directed by Michael Cuesta, Gary (played by Jeremy Renner) found by accident the CIA story while he was covering government seizures of houses which belonged to accused drug dealers. A shrewd strategy on the part of a beautiful woman (played by Paz Vega) and a mistakenly liberated court transcript made Gary tell the most dramatic story of his career. He was thrilled to be writing about something so important and, after some fear, his editor (played by Mary Elizabeth Winstead) and publisher (Oliver Platt) were excited by all the attention their publication was getting. However, the CIA didn't like this kind of publicity, and the Agency has ways of pushing back.

Kill the Messenger is not in the least an action thriller. It looks like it wants to work as both a political/psychological thriller and a character study, but it often gets bogged down under its own weight. Even though there is a clear chain of events, it often feels like we're going back and forth over the same issues as Gary repeatedly verbally wrestles with his sources and his bosses. There are some wonderful scenes, including several with Michael Sheen as a government man who tries to warn Gary off of his course, but some are a little overdone.

Kill the Messenger is worth seeing for Renner's work and for the information it provides about its time and its subject. Mainly, it will whet appetites for the books it's based on, which promise to be fuller experiences.

Tips

- Include the main information such as the name of the film, main characters and film type.
- Write a plot summary of the film briefly.
- Discuss one aspect of the film making, such as editing and costume design.
- Give an overall reaction to the film.

Part III Task

Assume that you have watched a new film lately and now you want to make some comments on it. Please write a film review with about 300 words.

Learning Objectives

Students will be able to:
- appreciate and describe some representative paintings;
- understand the vocabulary in painting;
- deepen their understanding of representative figures in Chinese painting;
- write a formal email to make a request.

Unit 2

Personages of Fine Arts

Lead-In

Task 1 Exploring the Theme

Watch a video and fill in the blanks with the information you get from the video.

The farm in Andrew Wyeth's eyes is special, because "there is a(n) 1)_____ about this place"; "there is a magic, the excitement of the 2)_____". Living there, Andrew Wyeth closely observed his neighbors, the Kuerners, and created many artworks with them as the subject. The Kuerners are 3)_____, letting Andrew wyeth come and go like a(n) 4)_____. In an interview, Andrew Wyeth says that he lost his father in an accident, and he 5) _____ it that he hadn't done his portrait. Carl 6)_____ him of his father in many ways. For instance, they both had the 7)_____ _____, Germanic power. So Andrew wyeth realizes "Here is my father still alive".

Task 2 Brainstorming

Answer the following questions. Discuss with your classmates and share your answers with the class.

1) Do you know any realist painters? Could you introduce one of his/her representative works?

2) Have you ever appreciated the paintings by Andrew Wyeth? What's your impression of the artist?

Task 3 Building Vocabulary

Talk with your classmates, and try to describe the following words and phrases in English.

> iconic egg tempera genre scene dry brush earth color

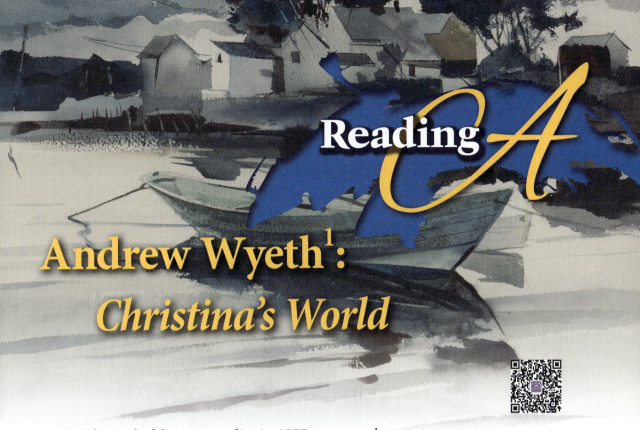

Reading A

Andrew Wyeth[1]: *Christina's World*

1 When asked by a journalist in 1977 to name the most **underrated** and **overrated** artists in the history of art, the art historian Robert Rosenblum chose to submit one name for both categories: Andrew Wyeth. Wyeth is an American realist painter whose life and career spanned the better part of the twentieth century. He produced in 1948 one of the most **iconic** paintings in American art, called *Christina's World* (Illustration 1), portraying a **desolate** Maine landscape with a single figure. This painting

underrate *v.* 低估
overrate *v.* 高估

iconic *adj.* 象征性的

desolate *adj.* 荒凉的

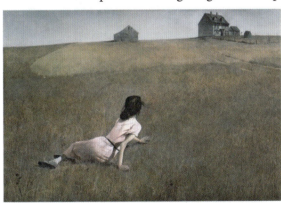

1. Andrew Wyeth (American, 1917—2009). *Christina's World*. 1948. Tempera on panel, 81.9cm × 121.3cm. The Museum of Modern Art, New York.

1 安德鲁·怀斯（1917—2009），美国现实主义画家。

has become one of the most recognizable images in the history of American art, along with James Abbott McNeill Whistler's *Arrangement in Grey and Black No.1* (Illustration 2), better known as *Whistler's Mother*, and Grant Wood's *American Gothic* (Illustration 3), a painting of a dour Midwestern farm couple in front of their homestead. *Christina's World* has been so widely reproduced that it has become a part of American

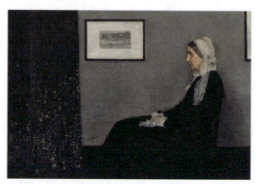

2. James Abbott McNeill Whistler (American, 1834—1903). *Arrangement in Gray and Black No.1* (the artist's mother). 1871. Oil on canvas, 144.3cm × 162.5cm. Musée d'Orsay, Paris.

3. Grant Wood (American, 1891—1942). *American Gothic*. 1930. Oil on beaver board, 78cm × 65.3cm. The Art Institute of Chicago, Chicago.

popular culture; and it has also **ignited** heated arguments—about America's self-image, cultural **parochialism** and taste. The arguments added a measure of controversy to Wyeth's career, up to his death in 2009. Although controversies surrounding the role of Wyeth's work in American postwar art have shaped his artistic legacy, the popularity of the painting endures. Not only is *Christina's World* one of the best known and loved images of American art, but in 1976 Wyeth was given a major one-man **retrospective exhibition** in the Metropolitan Museum.

2 Andrew Wyeth is the son of Newell Convers Wyeth, a distinguished **illustrator** and painter. Brought up breathing art, he proved talented at an early age. He had his first one-man show in New York when he was only 20. In 1939, he came to know a brother and sister called Olson, on a remote farm in Maine. He spent the summers there, painting the farm, the region and a series of remarkable **portraits** of Christina Olson until her death in 1967.

3 *Christina's World* is a modest-sized **genre scene**, painted in high detail with **egg tempera** on board. Set in the **stark**, barren landscape of coastal Maine, it **depicts** a young woman seen from behind, wearing a pink dress and lying in a mown field. Although she **reclines** gracefully, her upper torso, propped on her arms, is strangely alert; her **silhouette** is tense, almost frozen, giving the impression that she is fixed to the ground. She stares stock-still, perhaps with longing, perhaps with fear, at a distant farmhouse and a group of outbuildings, ancient and grayed to **harmonize with** the dry grass and overcast sky. The scene is familiar, even **picturesque**, but it is also mysterious: Who is this young woman, vulnerable but also somehow **indomitable**? What is she staring at, or waiting for? And why is she lying in a field?

4 The impact of *Christina's World* is troubling: The figure of the girl is twisted awkwardly in the expanse of grass, and she is focused on the house on the crest of the slope. This house and the second house directly behind Christina's head, and

ignite *v.* 点燃；激起

parochialism *n.* 偏狭；乡土观念

retrospective exhibition 回顾展

illustrator *n.* 插画家

portrait *n.* 肖像画

genre scene 风俗画
egg tempera 蛋彩画
stark *adj.* 荒凉的
depict *v.* 描绘
recline *v.* 斜倚；靠
silhouette *n.* 轮廓；剪影

harmonize with 与……协调

picturesque *adj.* 风景如画的

indomitable *adj.* 不屈不挠的；不服输的

Christina's body are linked **inexorably** on the three corners of a triangle. Yet the sense of huge distance is **overwhelming** and seems **unbridgeable** physically or psychologically, between the woman and the main house on which the gray sky sits so **claustrophobically**. Many, perhaps most people assume at once that the subject is an attractive young girl, an interpretation brought by what could be a youthful abandon in the grass, and by the slightness of the body, the adolescent fragility of the arms. In fact, Christina Olson was at this time a mature woman, somewhat **gaunt**, and so severely crippled that she proceeded by dragging herself on her arms. Several of Wyeth's initial rough drawings record his determination to discover the exact **articulation** of the **maimed** body, which in the finished painting seems to express both the tragedy and the joy of life with such vivid **poignancy** that the painting becomes a universal symbol of the human condition—and is recognized as such: The picture has had a continuing fan mail from people who have identified with it.

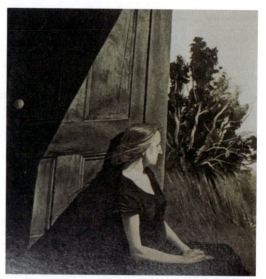

4. Andrew Wyeth (American, 1917—2009). *Christina Olson*. 1947. Tempera on panel, 83.8cm × 63.5cm. Curtis Galleries, Minneapolis.

Christina is sitting on the doorstep of her house. Late afternoon sun falls on her lined and wrinkled face and frail body, and it casts a strange shadow on the door behind her, which is as weathered as she is. She is looking out across the fields towards the sea: Wyeth said she reminded him of "a wounded seagull".

5 Wyeth has described his sequence of portraits of Christina: "I go from *Christina Olson* (Illustration 4), which is a formal one, a classic pose in the doorway, all the way through *Christina's World*, which is a magical environment, that is, it's a portrait but with a much broader symbolism, to the complete closeness of focusing in *Miss Olson* (1952). *Miss Olson* was a shock to some people who had the illusion that the person in *Christina's World* was a young, beautiful girl. And that is one reason why I did it, in order to break the image. But I didn't want to ruin the illusion really, because it's not a question of that. One has to have both sides—one, the highly poetic; the other, the close scrutiny…"

scrutiny *n.* 详细审查

6 Wyeth has denied any fundamental influence on his development from other painters, though he has acknowledged inspiration from artists as diverse as Winslow Homer[1] and Albrecht Dürer[2]. His affinities with the impassioned detail of Dürer (particularly the watercolors) are obvious, and his technique of dry brush over watercolor is close to Dürer's, and not far short of him in brilliance. In his large paintings, too, his techniques are traditional; he uses tempera rather than oil, with extreme sensitivity and with a range of earth colors. His practice is minute, laborious and slow, and the paintings are prefaced in great detail by preparatory drawings.

affinity *n.* 喜爱
impassioned *adj.* 充满激情的；热烈的
watercolor *n.* 水彩画
technique *n.* 技法
dry brush 干笔画法
far short of 差得很远
earth color 大地色
minute *adj.* 细致入微的

5. Andrew Wyeth (American, 1917—2009). *Miss Olson.* 1952.
Tempera on panel, 25 × 28½ in. Private Collection.

1　温斯洛·霍默 (1836—1910)，美国风景画画家、版画家。
2　阿尔布雷特·丢勒 (1471—1528)，德国画家、版画家。

7　Wyeth's work at its best demonstrates that the traditional subjects, media and techniques of Renaissance[1] painting can still result in images that have a profound significance. His work is also **quintessentially** American. In a sense, though so different in technique, he offers the rural counterpart to Edward Hopper's[2] earlier characterization of American urban townscape. A comparable sense of vastness, isolation and loneliness, invests the work of both, but is expressed by Wyeth in the intensity of his realization of detail.

(982 words)

quintessentially *adv.*
典型地；标准地

(Adapted from: [1] Piper, D. *The Illustrated History of Art*. California: Bounty Books Publisher, 2004. [2] Hoptman, L. *Wyeth Christina's World*. New York: The Museum of Modern Art, 2012.)

1　文艺复兴运动，发生在 14—17 世纪的欧洲，人们以古希腊罗马的思想文化来繁荣文学艺术。
2　爱德华·霍普 (1882—1967)，美国现实主义画家。

Part I Understanding the Text

Task 1 Global Understanding

1. Read the text, and identify the main ideas.

1) What is the importance of *Christina's World* in American art?

2) What is so special about the painting *Christina's World*?

2. Match the correct headings to the paragraphs below.

Paragraph 1 The Artist's Own Remark on the Work and the Sequence of Portraits

Paragraph 2 *Christina's World* Is Uniquely Influential in American Art History

Paragraph 5 The Artist's Life and Creation Background

Task 2 Detailed Understanding

1. Read the text again and choose the best answer to each question below.

1) Which of the following part is NOT true according to the passage?

 A. *Christina's World* is one of the most iconic paintings in American art.

 B. *Christina's World* has become one of the most recognizable images in the history of American art.

 C. There are different voices about Wyeth's works.

 D. People invariably sing praise of Wyeth's works.

2) According to the passage, the artworks by Wyeth may remind the viewers of other painters EXCEPT _____.

 A. Claude Monet B. Albrecht Dürer C. Winslow Homer D. Edward Hopper

Unit 2 Personages of Fine Arts

3) About Wyeth's artistic style, which of the following is true?

 A. He loves to demonstrate impassioned detail with his works.

 B. In large paintings, Wyeth shows unconventional techniques.

 C. The artist chooses "wet brush" over "dry brush" more often.

 D. The artist's paintings are not quintessentially American.

2. Answer the following questions according to the text.

1) In Paragraph 4, the author remarked that "Many, perhaps most people assume at once that the subject is an attractive young girl". What gives people such an impression?

2) How does the painting "become a universal symbol of the human condition"?

3) According to the details introduced throughout the passage, could you summarize the artistic style of Wyeth?

Part II Building Language

Task 1 Key Terms

The words or phrases below are related to painting. Discuss with your classmates and provide your understanding about each term in English.

1) reproduce: _____

2) retrospective exhibition: _____

3) illustrator: _____

4) portrait: _____

5) genre scene: _____

6) egg tempera: _____

7) watercolor: _____

8) technique: _____

9) dry brush: _____

10) earth color: _____

11) media: _____

Task 2 Vocabulary

Choose the correct word or phrase from the box below to complete each of the following sentences. Change the form where necessary.

underrate	overrate	iconic	reproduce	illustrator
depict	silhouette	picturesque	inexorably	overwhelming
diverse	impassioned	watercolor	technique	media

1) There are six major painting _____ (encaustic, tempera, fresco, oil, acrylic, watercolor), each with specific individual characteristics.

2) I think this speaker is _____ their economic influence. In fact, it is not as important as he describes.

3) She admitted that she had made a mistake: She used to _____ the new employee's ability and as a result, they had lost many great opportunities.

4) During that period, the painting _____ have been improved. Thus artists were able to depict people's life in a more detailed way.

5) Our cultures and individual behaviors are so wonderfully _____ that humans are more like an entire ecosystem than a single species.

6) In her speech, she made a(n) _____ appeal for peace.

7) Quietly, but _____, modern technologies are changing the way people travel.

8) A(n) _____ brand name is a brand name that is widely recognized and well-established.

9) Sound effects can _____ the sound of thunder in a highly authentic way.

10) My interest in art started from a landscape done in _____.

11) The evidence against him was _____. Now he has no chance to escape the punishment of justice.

12) The painting is renowned for presenting to the audience a(n) _____ view that only exists in one's memory or imagination.

13) Living in the city, we are accustomed to the dark and gray _____ of buildings against the sky.

14) Her mother was a well-known artist and book _____.

15) The wall was painted with a large mural _____ famous scenes from the country's history.

Part III Translation

1. Translate the following sentences into Chinese.

1) He produced in 1948 one of the most iconic paintings in American art, called *Christina's World*, portraying a desolate Maine landscape with a single figure.

2) Andrew Wyeth had his first one-man show in New York when he was only 20.

3) The painting depicts a young woman seen from behind, wearing a pink dress and lying in a mown field.

4) His affinities with the impassioned detail of Dürer (particularly the watercolors) are obvious, and his technique of dry brush over watercolor is close to Dürer's, and not far short of him in brilliance.

5) Wyeth's work at its best demonstrates that the traditional subjects, media and techniques of Renaissance painting can still result in images that have a profound significance.

2. Translate the following sentences into English.

1) 写实主义是艺术创作，尤其是绘画、雕塑、文学和戏剧中的常用概念。

2) 安德鲁·怀斯的部分题材是他身边的邻居，因为他一般不会离家很远。

3) 安德鲁·怀斯并没有在专业的美术院校学习，而是从小就在父亲的工作室接受系统的绘画训练。

4) 在怀斯的作品中，有种令人神往的力量，能唤起人们对故乡的思念，以及对逝去时光的回忆。

5) 中国画具有鲜明的民族形式和艺术特色——画家仔细研究对象后发现其结构的规则，然后在脑海中再现该对象。

Reading B

Chinese Painting at the Turn of the Century

1 The overthrow of the Qing dynasty by the Revolution of 1911[1] not only changed China's political structures, but also **accelerated** and sharpened debates over "traditional" culture, which was the object of sharp critique and robust defense at that time. Visual art formed part of the cultural battleground, becoming a site of struggle between **contending** visions of China's future. Some proposed total "Westernization". Others opposed it strongly. A widely supported position aimed at an integration of the best parts of what were seen as total artistic entities.

accelerate v. （使）加速；加快

contend v. 竞争；争夺

2 The creation of a category of "modern" Chinese art implied the creation of its opposite, "traditional" Chinese art, which was the label often easily given to work like a painting by Chen Hengke[2]. The format and medium in Chen's *Studio by the Water* (Illustration 1) had a very long history in China. Its subject matter had **engaged** artists in China for centuries. But

engage v. 吸引住（注意力、兴趣）

1 辛亥革命。
2 陈衡恪 (1876—1923), 中国近代美术家、艺术教育家。

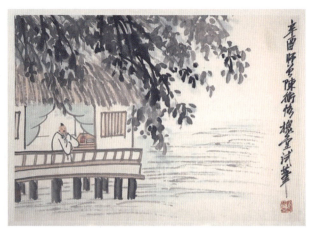

1. *Studio by the Water*, album leaf on paper, by Chen Hengke, dated 1921.

unpretentious *adj.* 谦虚谨慎的；不事张扬的

conservatism *n.* 保守主义

modernity *n.* 现代性

conscious *adj.* 有意识的，意识到……的

pictorial *adj.* 图画的

subjectivity *n.* 主观性；主观

intrinsically *adv.* 本质地

mechanically *adv.* 机械地；呆板地

resonance *n.* 共鸣；共振

venerable *adj.* 值得尊敬的；珍贵的

revered *adj.* 崇敬的

individuality *n.* 个性；个人（或个体）特征

in style, Chen's **unpretentious** image is not that of a work of the eighteenth century or the sixteenth. It doesn't represent an unthinking **conservatism** or a simple resistance to **modernity**. Rather, it is a **conscious** and sophisticated awareness of what modernity might be in **pictorial** terms.

3 In the same year when he painted this picture, 1921, Chen published an important theoretical essay entitled *The Value of Literati Painting*. In this essay, Chen argued that elements of **subjectivity** and self-expressionism exist in Chinese painting, making it **intrinsically** "modern" art. He held that there was no necessity to **mechanically** acquire the representational canons of European painting. The "spirit **resonance**" (qiyun) of Xie He's[1] **venerable** and **revered** "Six Laws" was now understood by Chen Hengke, and other fellow members of groups like the "Chinese Painting Research Society"[2]. It provided a charter for the **individuality** and subjective expression which were a necessary part of a "modern" form of art.

4 As a teacher of painting, Chen was associated with Peking University, the leading intellectual center of that time. In the years before his early death, he would have encountered there a younger artist who took a very different tack in his response to the creation of art that was both "modern" and "Chinese". This

1 谢赫（479—502），南朝齐梁时期画家。

2 国画研究会。

was the name most closely associated today with the project to make a self-consciously "new" Chinese art by blending East and West—Xu Beihong[1].

5 Xu was **canonized** as the "founding father" of modern Chinese art, the most important Western-style Chinese painter of the early twentieth century. Xu Beihong was raised in Yixing and went to Shanghai at the age of twenty. In 1917, he studied art in Japan, spending nearly a year there. From 1919 to 1927, he spent eight years in Europe, studying in Paris and Berlin. On his return to China, Xu taught at the South China Art Academy[2] in Shanghai and at the Art Academy in Beijing[3]. Moving to Nanjing, he worked as a professor at the National Central University from 1929 to 1936. In 1946, he became the director of the Beiping Art Academy (from 1950, renamed as the National Central Academy of Fine Arts), a post he held until his death in 1953.

canonize *v.* 推崇

6 Like Lu Xun[4], Xu Beihong, with both Chinese and foreign training, remained very much the **Confucian** scholar-official, committed to highly idealistic pursuits.

Confucian *adj.* 儒家的；儒学的

7 When Xu Beihong returned to Beijing in 1918, he became involved in the New Culture Movement[5]. He adopted Cai Yuanpei's[6] **dictum** that in the new society, religion should be replaced by the fine arts. Xu **attributed** the decline of Chinese painting to "traditionalism" and "the loss of the independent and professional status (of the painter)". To transform Chinese painting, he argued, the painter must "keep what is good… change what is bad… and adopt what he can from Western painting". In addition, the Chinese "must stop copying the ancient masters… and instead apply modern technology to a disciplined **rendering** of 'true' painting".

dictum *n.* 格言

attribute *v.* 把……归因于；认为……是由于

rendering *n.* 演绎；表演

1 徐悲鸿 (1895—1953)，中国现代画家、美术教育家。
2 上海华南艺术学院。
3 北京艺术学院。
4 鲁迅 (1881—1936)，伟大的文学家、思想家。
5 新文化运动，发生于 20 世纪初，是由中国一些先进知识分子发起的反对封建主义的思想解放运动。
6 蔡元培 (1868—1940)，中国近代教育家。

8 Xu's mission was to bring Chinese painting into the twentieth century. He saw the conception of modernity as the application of "scientific" methodology to the representational practice of painting. "Artists, like scientists," he wrote, "are guided by the search for truth. Just as mathematics is the basis of science, figure drawing provides the foundation for art."

9 Xu interpreted Western art through Chinese theory. Western figural representation, for example, was to be understood in terms of the traditional Chinese dichotomy between form-likeness and spirit-resonance:

10 It is said that while Chinese art values spirit-resonance, Western art emphasizes form-likeness, not knowing that both form-likeness and spirit-resonance are a matter of technique. While "spirit" represents the essence of form-likeness, "resonance" comes with the transformation of form-likeness. Thus, for someone who excels in form-likeness, it is not hard to achieve spirit-resonance. Look at the relief sculptures at the Parthenon, carved some 2,500 years ago in ancient Greece, and see how wonderful they are! It is simply not true that all Western art has no resonance.

11 Xu Beihong's visits, in 1919, to the British Museum[1] and the Musée du Louvre[2] sparked his interest in building a collection of paintings and reproductions to advance the education of the arts in China. Throughout the late 1920s and early 1930s, while he actively exhibited his own paintings in Europe and Singapore, he also campaigned for the establishment of a national art museum. His lifelong desire to found a museum was finally realized after his death. In 1953, his family donated his collection to the country and the Xu Beihong Memorial Museum was established in Beijing the following year.

12 As a collector, Xu's tastes in ancient Chinese paintings

1 大英博物馆，位于英国伦敦新牛津大街北面的罗素广场。
2 卢浮宫博物馆，位于法国巴黎市中心的塞纳河北岸。

were eclectic. By and large, he preferred realism as exemplified in figural and floral paintings of the Song period. In general, he was not sympathetic to early Chinese landscapes. For him, they were products of naturalism, which implied decadence and vulgarity and was responsible for the decline and weakness of later Chinese art.

eclectic *adj.* 兼收并蓄的
by and large 大体上；总的来说

13 Citing the rich heritage of mythological and historical subject matter in the Greco-Roman tradition, Xu enumerated the range of source material from Chinese history and culture. Beginning in the late 1920s, Xu tackled a series of ambitious paintings on historical subjects.

mythological *adj.* 神话的；神话学的
enumerate *v.* 列举；枚举

14 Xu's struggle to create a technical synthesis of Chinese and Western methods began in 1931, when he painted a large multifigured composition, *Jiu Fanggao (the Astute Judge of Horses)* (Illustration 2), in the traditional medium of Chinese brush, with ink and color on paper. Creating a work with brush and ink on absorbent paper does not allow for the correction, or repainting of the image once it has been committed to paper. Xu therefore made several versions of the composition before he arrived at one that was acceptable. The final image was his seventh attempt.

ink and color on paper 纸本设色
absorbent paper 吸水纸；生宣
composition *n.* 构图

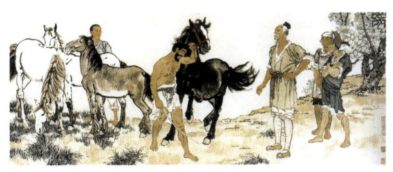

2. *Jiu Fanggao (the Astute Judge of Horses)*, ink and color on paper, by Xu Beihong, dated 1931.

15 Long fascinated with paintings of animals, Xu made horses. Horse is a traditional symbol of high spirit and courage—his specialty. In the charcoal *Man with Horse* (Illustration 3), made about 1924, he showed his mastery of the animal forming the academic manner of Dagnan-Bouveret. As a reformer, he

charcoal *n.* 炭笔（画）
mastery *n.* 精通

Unit 2 Personages of Fine Arts

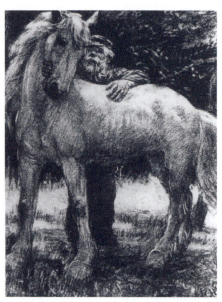

3. *Man with Horse*, Charcoal on paper, by Xu Beihong, dated 1924.

believed that a solid foundation in the techniques of Western art could get Chinese painting away from its decline. He described his own immersion in such techniques:

quick sketch 速写

anatomy *n.* 解剖;解剖学

musculature *n.* 肌肉系统

16　In painting horses, I have made thousands of **quick sketches**. Having studied the horse's **anatomy**, I am thoroughly versed in its bone structure and **musculature**, and in carefully observing its movement and spirit I have developed a special insight into this subject.

(1220 words)

(Adapted from: [1] Clunas, C. *Art in China*. London: Oxford University Press, 2009. [2] Wen, C. F. *Between Two Cultures, Late-Nineteenth- and Early-Twentieth-Century Chinese Painting*. New York: Metropolitan Museum of Art, 2001.)

Part I Understanding the Text

Task 1 Global Understanding

1. Read the text, and identify the main ideas.

1) Could you summarize Chen Hengke's artistic features?

2) Discuss with your partners and summarize the main opinions of Xu Beihong.

2. Write down the key ideas of each paragraph below.

 Paragraph 11: _____

 Paragraph 12: _____

 Paragraph 14: _____

Task 2 Detailed Understanding

1. Answer the following questions according to the text.

1) What is the debate about in Paragraph 1?

2) What are Chen Hengke's works normally labeled?

3) Are Chen Hengke's paintings as traditional as they are labeled?

2. Discuss the following questions with your partner.

1) According to Xu Beihong, how should artists transform Chinese painting?

2) How does Xu Beihong understand "form-likeness and spirit-resonance"?

3) What does Xu Beihong think of early Chinese landscapes?

Part II Building Language

Task 1 Key Terms

The words or phrases below are related to fine arts. Discuss with your classmates and provide your understanding about each term in English.

1) pictorial: _____

2) rendering: _____

3) figural representation: _____

4) ink and color on paper: _____

5) absorbent paper: _____

6) composition: _____

7) charcoal: _____

8) quick sketch / sketch: _____

9) subject: _____

10) literati painting: _____

Task 2 Vocabulary

Choose the correct word or phrase from the box below to complete each of the following sentences. Change the form where necessary.

accelerate	contend	engage	unpretentious	conscious
pictorial	subjectivity	mechanically	individuality	Confucian
attribute	eclectic	by and large	mythological	mastery

1) The tennis player claims that she will _____ for the championship this year.

2) Although she was wealthy, she lived in a(n) _____ house.

Unit 2 Personages of Fine Arts

3) If at any point you feel stressful, make a(n) _____ effort to relax.

4) It is a movie that _____ both the mind and the eye.

5) The artist shares with the viewers her feelings in a(n) _____ form, that is through her paintings.

6) With his eyes blankly fixed on the witch, he answered all the questions _____.

7) Some of their stories were based on historical fact, but most were _____.

8) Employment rate has dropped a little in the recent quarter. But taking it _____, the conditions of employment are good.

9) We were amazed by the style of her new house. It is a(n) _____ mix of Japanese tea drinking and English country garden.

10) In teaching and researching, we should invariably seek objectivity and avoid _____.

11) She is trying to express her _____ in many exterior ways, such as the hair style, clothes, etc.

12) China is an ancient civilization. For over two thousand years, people's attitudes towards education have been strongly influenced by _____ philosophy.

13) A considerable amount of people tend to _____ their success to external causes such as luck.

14) Please bear in mind that _____ of any art or skill takes time.

15) Along with the development of local economy, the pace of life has _____ in recent years.

Part III Translation

1. Translate the following sentences into Chinese.

1) The subject matter of Chen's *Studio by the Water* had engaged artists in China for centuries.

2) In the same year when he painted this picture, 1921, Chen published an important theoretical essay entitled *The Value of Literati Painting*. In this essay, Chen argued that elements of subjectivity and self-expressionism exist in Chinese painting, making it intrinsically "modern" art.

3) While "spirit" represents the essence of form-likeness, "resonance" comes with the transformation of form-likeness. Thus, for someone who excels in form-likeness, it is not hard to achieve spirit-resonance.

4) Citing the rich heritage of mythological and historical subject matter in the Greco-Roman tradition, Xu enumerated the range of source material from Chinese history and culture.

5) Xu therefore made several versions of the composition before he arrived at one that was acceptable. The final image was his seventh attempt.

2. Translate the following sentences into English.

1) 国画 (Chinese painting) 是世界上最古老的艺术传统之一。绘画时用毛笔蘸黑色或彩色颜料在纸或绢上作画。

2) 根据表现手法，国画可分为写意 (the Xieyi School) 和工笔 (the Gongbi School) 两大类。

3) 写意派以自由表达和形式夸张为特点；工笔派则注重以精细的笔法描绘细节。

4) 纵观历史，不同时期的国画都不同程度地反映出人们的社会意识。

5) 许多中国画家既是诗人，又是书法家。他们经常会在自己的画上亲手添加诗作。

Writing Skills

Making an Email Request

Part I Preparation

Task 1 Introduction

When we ask somebody for something in a business or professional email, it's essential that we both explain what we want clearly and ask them in the right way. For a formal email or letter of request to work, it needs to be easy to read for the person receiving it. And we do this with a good structure and the right vocabulary we use in it.

Task 2 Preparation Task

The following are the sentences we might use in making an email request. Fill in each of the blanks with the corresponding letter given in the box.

> A. we requested
> B. clarify
> C. which we hope you could answer
> D. could you also please confirm
> E. we are considering
> F. We would be very grateful if

1) I am writing in reference to the current situation with the Skipton Airport Project. We have a number of questions _____.

2) We would appreciate it if you could _____ what the current issues are, and confirm when you expect them to be resolved.

3) And lastly, _____ extending the period of the post-installation support from your company from 6 months to 12 months.

4) _____ you could provide us with a quote for this extension.

5) At the end of the last meeting _____ a copy of the latest project update report. Unfortunately, we have still not received it. We would appreciate it if you could forward this to us.

6) By the way, _____ whether the post-installation support covers the equipment 24 hours a day?

Part II Reading Example

Dear Allen,

Would you please assist me as I begin my preparation to teach in your school this fall? Before I leave for China, I'd like to know more on the following items:

- What kind of students will I teach?
- What specific courses do you want me to teach?
- Are textbooks available? Should I bring some teaching materials?
- What degree of proficiency should I have in Chinese language?

I will arrive on August 25th. Though it is four months away, I wish to have a better preparation for the job. Consequently, receiving your reply would help me a lot in achieving that goal.

Yours sincerely

John Smith

Tips

- The letter includes:
 - ✓ the reason for writing;
 - ✓ the nature of the problem;
 - ✓ the outcome you'd like;
 - ✓ an apology for the inconvenience.
- To make polite requests, use the phrase *I would be grateful if you could…*
- Using nouns instead of verbs can make your writing sound more formal.
- Sign off *Yours sincerely*, if you know the person's name and *Yours faithfully*, if you don't.

Part III Task

Suppose you are a fresh graduate. Write a request letter to Roger Williams, the recruiter, for details of the job interview that you will go for next week. The letter should be around 120 words.

Learning Objectives

Students will be able to:

- understand the musicological terms;
- describe the features of Tchaikovsky's *Sixth Symphony in B Minor*;
- understand the vocabulary of music criticism and gain a critical view on the impact of globalization on music cultures around the world;
- write an opinion essay.

Unit 3

Music Appreciation

Lead-In

Task 1 Exploring the Theme

Look at the pictures and answer the questions.

1) Do you know the person in the pictures? What might be his profession?

2) What kind of artistic form can you see from the picture? Describe the actress's make-ups and dressing features.

Task 2 Brainstorming

Answer the following questions. Discuss with your classmates and share your answers with the class.

1) What are the major themes or purposes of music composition?

2) What influences might globalization exert on regional music?

Task 3 Building Vocabulary

Talk with your classmates, and try to describe the following words and phrases in English.

| posthumous | mundane | fluke | coup-de-théâtre | prism |

Reading A

Tchaikovsky's *Sixth Symphony in B Minor*

Forget, first of all, its mis-translated **moniker**. Tchaikovsky's final symphony might be about death, but it's the piece he termed "the best thing I have composed" and is a confident and supremely energetic work.

moniker *n.* 绰号；名字

1 Let's get this clear: Tchaikovsky's *Pathétique Symphony*[1] is not a musical suicide note; it's not a piece written by a composer who was dying; it's not the product of a musician who was **terminally** depressed about either his compositional powers or his personal life; and it's not the work of a man who could go no further, musically speaking. It shouldn't even be called the *Pathétique*. Tchaikovsky himself, having supposedly approved his brother's Russian word Патетическая ("Patetitčeskaja"[2]) for the work (a better translation of which is "passionate" in English), sent his publisher the instructions that it was simply his *Sixth Symphony in B Minor*[3], dedicated to his nephew Bob Davydov. That's how the piece appeared when Tchaikovsky himself conducted the premiere in St. Petersburg on October

terminally *adv.* 晚期的；致命的

1 *Symphony No. 6 in B Minor, Op. 74*, 柴可夫斯基著名作品《悲怆》，创作于 1893 年 2 月至 8 月。
2 俄语，意为"悲惨"。
3 柴可夫斯基著名作品《B 小调第六交响曲》，又名《悲怆》。

28, 1893. It was only in its first posthumous performance, three weeks later, that it was called the "Pathétique", a moniker that has stuck ever since.

2 Instead, the *Sixth Symphony* is a vindication of Tchaikovsky's powers as a composer. It is the piece that he described many times in letters as "the best thing I ever composed or shall compose", a work whose existence proved to him that he had found a way out of a symphonic impasse, which represented a return to the heights of his achievement as a composer, and brought a deep, personal satisfaction that he hadn't felt in years.

3 Yet, the *Sixth Symphony* is about death. It's the fulfilment of a program that Tchaikovsky had sketched for a *Symphony in E Flat Major* that he discarded in 1892. "The ultimate essence…of the symphony is life. First part—all impulse, passion, confidence, thirst for activity—must be short (the finale death—result of collapse). Second part love; third disappointments; fourth ends dying away (also short)."[1] While that isn't a precise description of what became the *Sixth Symphony*, in the broadest sense of a symphony whose final image is of musical, emotional, and physical collapse, there is a clear connection between the two.

4 But frankly, this is a piece about a struggle between the force of life and an inevitable descent to an exhausted physical and emotional demise. The connotation is obvious to anyone who has heard the piece or ever lived through the dark moments of their mundane life. In the *Sixth Symphony*'s concluding movement, Tchaikovsky creates a new shape for the symphony. That slow, lamenting finale turns the entire symphonic paradigm on its head, and changes at a stroke the possibility of what a symphony could be: Instead of ending in grand public joy, the *Sixth Symphony* closes with private, intimate, personal pain.

5 Some might say: Exactly! That's why this symphony is a

1 引自柴可夫斯基个人写作札记的英语译本。

reflection of Tchaikovsky's autobiography! He must have been depressed, or suicidal to have composed this! And there's more: The *Russian Orthodox Requiem* chant even makes a blatant appearance in one of the most dramatic coups-de-théâtre in the first movement! You see? He knew he was dying!

6 The only possible refutation to this is: That's nonsense. To take some examples from elsewhere in musical history: Hector Berlioz's[1] music too is full of intimations of mortality, but he kept going for decades after dreaming of his own execution in his *Fantastic Symphony*; Beethoven didn't expire after he faced the limits of human mortality in the *Missa Solemnis*[2]; and even Gustav Mahler[3] remained alive just after he had crossed the border into silence at the end of his *Ninth Symphony*. In fact, if every composer, author, painter, or poet had died after making their greatest works about death, none of them would have been around for very long. It is pure, tragic coincidence that Tchaikovsky should die of cholera a few days after conducting the *Sixth Symphony* at the age of just 53—a piece, to reiterate, that he actually composed in good mental and physical health—but that's all it is. We do this symphony a terrible injustice if we only see and hear it through the murky prism of myth, story, and half-truth that now swirls around.

7 So yes, this symphony is about a battle between a stubborn life energy and an ultimately stronger force of oblivion that ends up in a terrifying exhaustion, but what makes the piece so powerful is that it's about all of us, not just Tchaikovsky. That's because of how Tchaikovsky makes the musical and symphonic drama of the piece work. So when you're listening to the piece, listen to how the cry of pain, which is the climax of the first movement, becomes a musical premonition of the descending

blatant *adj.* 公然的；明目张胆的

coup-de-théâtre *n.* 令人惊讶或意想不到的事件转折

refutation *n.* 驳斥；反驳

expire *v.* 去世；（因到期而）失效；终止

cholera *n.* 霍乱

reiterate *v.* 反复地说；重申

murky *adj.* 复杂的；难以理解的；朦胧的

prism *n.* 棱镜

swirl *v.* 流传；旋动

oblivion *n.* 摧毁

premonition *n.* 预感

1 艾克托尔·柏辽兹（1803—1869），法国作曲家，法国浪漫乐派的主要代表。代表作有《幻想交响曲》《葬礼与凯旋交响曲》，歌剧《特洛伊人》等。
2 《庄严弥撒》，即《D大调庄严弥撒》，是贝多芬1819年至1823年间创作的作品。
3 古斯塔夫·马勒（1860—1911），奥地利作曲家、指挥家，现代音乐会演出模式的缔造者。代表作有交响乐《巨人》《复活》和《大地之歌》。

scales of the last movement. Listen to how the final bars of the third movement create one of the greatest, most thrilling, but most empty of victories in musical history, at the end of which audiences often clap helplessly, thinking they have arrived at the conventionally noisy end of a symphonic journey. But then, we're confronted with the **devastating** lament of the real finale that ends with low, **tolling** heartbeats in the double-basses that at last expire into silence.

devastating *adj.* 毁灭性的

toll *v.* （鸣）丧钟；敲钟

8 That silence was its own kind of victory for Tchaikovsky. He knew this piece helped him regain his confidence as a composer, and that he had re-invented the symphony on his own terms, as well as for so many composers who came after him. Mahler, Dmitriy Shostakovich[1], and many others could not have composed the symphonies they did without the example of Tchaikovsky's *Sixth Symphony*. It's just a terrible **fluke** of fate that this was his last symphony, and not the beginning of what could have been his most exciting creative period as a composer.

fluke *n.* 意外；偶然；侥幸

(966 words)

(From *The Guardian* website, edited and rewritten by the editor of the chapter.)

1 德米特里·肖斯塔科维奇（1906—1975），作曲家，被誉为20世纪最重要的作曲家之一。代表作有《第七交响曲》《第十四交响曲》等。

Part I Understanding the Text

Task 1 Global Understanding

1. Read the text and decide whether the following sentences are true (T) or false (F).

(　　) 1) Tchaikovsky approved his brother's pick of the Russian word "Патетическая" for the work and thus named it "Pathétique" at its world premiere.

(　　) 2) Tchaikovsky was very excited by his work as he wrote in letters to his friends that it represented a return to the heights of his achievement as a composer, and brought him a deep, personal satisfaction.

(　　) 3) Tchaikovsky's description of the *Six Symphony* was that its "ultimate essence is life", though it is about death.

(　　) 4) The *Six Symphony* is a piece about a struggle between the force of life and an inevitable fading into the demise of everything.

(　　) 5) Tchaikovsky knew he was about to die when he was composing the *Six Symphony*, which explains why the *Russian Orthodox Requiem* chant even made an appearance in one of the most dramatic movements.

2. Write down the key idea of each paragraph below.

Paragraph 4: _____.

Paragraph 6: _____.

Paragraph 7: _____.

Task 2 Detailed Understanding

1. Read the text again and choose the best answer to each question below.

1) What is the connection between Tchaikovsky's *Six Symphony* and his *Symphony in E Flat Major*?

 A. Both are about life and death.

 B. They both deliver the same sense of impulse, passion, confidence and disappointment.

 C. Both of their final image are of musical, emotional and physical collapse.

 D. The *Symphony in E Flat Major* was later rearranged and became the *Six Symphony*.

2) The author believes the connotations behind the *Six Symphony* _____.

 A. infer the composers' struggle with his depression

 B. can be easily caught for anyone who has ever lived through the dark moment of his/her mundane life

 C. represent the reflection of the author's life story

 D. refer to Tchaikovsky's determination to turn the symphonic paradigm upside down

3) What makes the *Six Symphony* so powerful is that _____.

 A. it is about a battle between the life-energy and a stronger force of oblivion

 B. it is about all of us, not just the composer himself

 C. Tchaikovsky makes the musical and the symphony full of dramatic effects

 D. the powerful effect is created by the cry of pain and the climax of the first movement

2. Answer the following questions according to the text.

1) What is the new shape that Tchaikovsky created for the symphony?

2) To those who argue that the *Six Symphony* is the reflection of Tchaikovsky's life, what cases can one quote to refute such opinions?

3) What might be the highlights when you listen to the *Six Symphony*?

Part II Building Language

Task 1 Key Terms

The words or phrases below are related to music. Discuss with your classmates and provide your understanding about each term in English.

1) movement: _____

2) finale: _____

3) symphony: _____

4) descending scale: _____

5) double bass: _____

6) bars: _____

7) mass: _____

8) concerto: _____

9) sonata: _____

10) cantata: _____

Task 2 Vocabulary

Choose the correct word or phrase from the box below to complete each of the following sentences. Change the form where necessary.

vindication	sketch	demise	lament	premonition
reiterate	expire	oblivion	terminal	blatant
discard	refute	swirl	murky	mundane

1) An unexpected victory in the local election save him from political _____.

2) She spoke of the professional woman's _____ that a woman's judgment is questioned more than a man's.

3) Initially you only need to submit a proposal which briefly _____ out your ideas.

4) He called the success a(n) _____ of his party's economic policy.

5) Isabelle is quick to _____ any suggestion of intellectual snobbery.

6) He endured excruciating agonies before he finally _____.

7) But I do _____, anyone caught acting in breach of a prohibition order is liable to two years' imprisonment.

8) Outsiders will continue to suffer the most _____ discrimination.

9) As the speeches went on and on, she was suffering from _____ boredom.

10) Smoking, rather than genetics, was the cause of his early _____.

11) The show was just another _____ family sitcom.

12) She had a sudden _____ of what the future might bring.

13) A(n) _____ cigarette sparked a small brush fire.

14) From the story she found a(n) _____ world of fraud and secret deals.

15) Rumors of a takeover began to _____ around the stock markets.

Part III Translation

1. Translate the following sentences into Chinese.

1) It was only in its first posthumous performance, three weeks later, that it was called the "Pathétique", a moniker that has stuck ever since.

2) It is the piece that he described many times in letters as "the best thing I ever composed or shall compose", a work whose existence proved to him that he had found a way out of a symphonic impasse.

3) Instead of ending in grand public joy, the *Sixth Symphony* closes with private, intimate, personal pain.

4) We do this symphony a terrible injustice if we only see and hear it through the murky prism of myth, story, and half-truth that now swirls around.

5) We're confronted with the devastating lament of the real finale that ends with low, tolling heartbeats in the double-basses that at last expire into silence.

2. Translate the following sentences into English.

1) 音乐是真正的通用语言,无论哪里的人都能理解。因此,每个国家,每个时代,总有人热切而严肃地讲这门语言。

2) 一段意蕴丰厚的旋律很快能传遍全球,一段言之无物的旋律立刻销声匿迹,这说明内涵丰富的旋律更容易被人所理解。

3) 音乐讲述的不是事物,而是纯粹的悲喜。因此,音乐虽然不直接诉诸头脑,对心灵却有千言万语。

4) 第二次世界大战刚刚结束,在欧洲那些满目瓦砾的城市里,音乐会已经开始,衣衫褴褛、伤痕累累的人们走进音乐厅。

5) 古琴深受孔子和先哲们所喜爱,是中国最重要的乐器。古琴被赋予了形而上学的意义,具有表达深切情感的功能。

Reading B

Contemporary Chinese Music and Its Globalized Present

1 It is no secret that Chinese music has been globalizing in Chinese ways. To probe such a complex and dynamic phenomenon, the critical question to ask is not whether the music that longer qualifies as quintessential Chinese expressions has been so stylistically transformed by global forces and styles, but what and how Chinese and global elements have interacted with one another in the production and consumption of the music, and what meanings the processes have generated. Simply interpreting the globalization of Chinese music as a process of external forces transforming Chinese sonic expressions undermines Chinese agency.

2 Chinese people produce and consume their own music actively and creatively. They strategically manipulate globalizing forces and resources to serve their musical needs and musically negotiate themselves with others. Hence, globalized Chinese music needs to be approached as a phenomenon built with diverse Chinese and non-Chinese elements which can hardly be meaningfully split from one another. Anyone who has stayed in China for extended periods and engaged in substantial ways

quintessential *adj.* 典型的；典范的

sonic *adj.* 声音的；声波的
undermines *v.* 逐渐削弱
manipulate *v.* 操控；操纵

with her people, sounds, and sights will have experienced the phenomenon and noticed how its diverse elements interact and coordinate in their own ways.

3 As demand for contemporary Chinese instrumental music increases, Chinese theorists and musicians soon developed a new **sonority**. It is a sonic texture that would favorably compare with Western art music or the international standard. On the other hand, it could also effectively project China's new outlook, while connecting it to historical and cultural roots. This **hybrid** has **rendered** the distinctive sonority more widespread and homogenizing. Such sound effect can now be found in some modern performances of *Kunqu*[1], one of the most classical forms among Chinese operas.

4 Responding to the new development, new forms of marketing have emerged. Some electronic outreach programs, for instance, online streaming services for distance learning/performance started to sparkle. Such initiatives reveal the cultural, social, and individual links in globalized Chinese music. In fact, contemporary Chinese instrumental music would not have become so **prevalent** if it was not supported by all kinds of Chinese music **practitioners** and audiences.

5 During many years of cultural exchanges, Chinese people have also brought their globalized and **hybridized** contemporary Chinese instrumental music to their new homes in Australia, Europe, North America and beyond. As a result, throughout the globalized world, wherever there are Chinese people, there is Chinese music, which often means contemporary Chinese instrumental music, whether it is played on the piano, the *guzheng*[2], or with some kind of mixed **ensembles**. Many overseas Chinese communities have their own professional or semi-professional orchestras, **perpetuating** and spreading their Chinese music to the host communities. Often is the case that immigrant Chinese musicians collaborate

sonority *n.* 洪亮；声响效果

hybrid *n.* 合成；混杂

render *v.* 使成为；使变得

prevalent *adj.* 普遍的；流行的

practitioner *n.* 从业者

hybridize *v.* 混合；杂交

ensemble *n.* 合奏

perpetuate *v.* 使永久化；持续

1 昆曲，原名"昆山腔"（简称昆腔），中国古老的戏曲声腔、剧种。
2 古筝，中国传统弹拨乐器。

with local and non-Chinese artists, creating music that fuses diverse genres and styles, ranging from blues to zydeco.

zydeco *n.* 柴迪科舞曲

6 As a matter of fact, the ways native and overseas Chinese directly and indirectly shape contemporary Chinese instrumental music constitute a unique but not isolated Chinese national image. Similar interactions between Chinese/local and non-Chinese/global elements manifest themselves in the genres of Chinese concert music, vernacular songs, and minority music. Chinese concert music that is created by Chinese composers with the language of Western or international concert music, holds musical imaginations of the Chinese self and its interactions with the Western other. Many contemporary Chinese elites esteem the genre because they believe it is a contemporary and serious expression, one that is intrinsically meritorious and one that appeals to both Chinese and non-Chinese alike. Implementing this belief, Chinese conservatories devote a lot of human and material resources to train Chinese pianists, violinists, singers, conductors, and composers so that they can favorably shine among their Western counterparts.

constitute *v.* 构成；组成；（被认为或看作）是

manifest *v.* 展示；展现

vernacular *n. /adj.* 方言（的）；土语（的）

esteem *v.* 尊重

meritorious *adj.* 值得称赞的

implement *v.* 实施；执行

7 Among the many artists whose efforts have shaped contemporary Chinese music in the world, Zhou Long[1] is cited by the *New York Times* as one of the leading Chinese composers, "injecting a new vitality into the American classical music scene". In 2003, the American Academy of Arts and Letters[2] awarded Zhou Long its Academy Award in Music, recognizing his lifetime achievement, saying, "unlike many composers of today working between cultures, Zhou Long has found a plausible, rigorous, and legitimate way of consolidating compositional methods and techniques that allow him to express brilliantly both his experiences as a composer of Western music and his considerable knowledge of his native

inject *v.* 注入；引入

plausible *adj.* 合理的
rigorous *adj.* 严谨的；谨慎的；细致的
consolidate *v.* 加固；巩固

1 周龙（1953— ），美籍华裔作曲家，第一个获得普利策音乐奖的亚裔音乐家。
2 美国艺术与文学学会，又译为美国艺术文学院，成立于1898年，总部位于纽约，是支持美国文学、音乐及艺术发展的组织。

China. In his music, Zhou Long displays a stunning, quasi-tactile orchestral imagination that dramatically demonstrates his skill of embedding elements of the two cultures in a consistent, seamless, and original musical language."

8 Zhou spent his early life in Beijing and received instructions on the piano at a young age. He was educated at the Central Conservatory of Music[1] (1977), later at Columbia University, New York where he earned a D.M.A[2] (1993). Subsequently he served as music director of a New York-based ensemble and later presided as distinguished professor of music composition at the University of Missouri—Kansas City[3]. Much of his works was influenced by his experience in China's countryside, though he also drew inspiration from ancient Chinese poetry. Among Zhou's most famous compositions was the music he created for *Madame White Snake*[4], a vivid opera based on a Chinese folk legend, for which Zhou earned the 2011 Pulitzer Prize for music. Upon his winning, the *Opera News*[5] wrote, "Giving voice to sweeping melodies worthy of Puccini[6] without sounding imitative, and employing such vocal effects as bent pitches and slides to suggest the unique idiom of Peking Opera, Zhou wove both aesthetics into a unique whole, creating a vivid and freestanding musical world of his own." In 2016, Zhou was enshrined into the New York Foundation for the Arts (NYFA) Hall of Fame[7]. That same year, Zhou and his wife, Chen Yi[8], set

1 中央音乐学院。
2 全称为 Doctor of Musical Arts，即"音乐艺术博士"，是音乐专业的博士学位。
3 密苏里大学堪萨斯分校，是位于美国密苏里州堪萨斯城的一所公立大学，创办于 1933 年。
4 歌剧《白蛇夫人》，由作曲家周龙创作，首演于 2010 年。故事取材于中国民间传说《白蛇传》，歌剧分为"春（唤醒）""夏（热恋）""秋（蜕变）"与"冬（负心）"四幕。2011 年，周龙凭借《白蛇夫人》荣获普利策音乐奖。
5 杂志《歌剧新闻》，美国古典音乐杂志，由美国大都会歌剧院协会出版，首刊出版于 1936 年。
6 普契尼（1858—1924），意大利著名作曲家，代表作有歌剧《波希米亚人》《托斯卡》和《蝴蝶夫人》等。
7 纽约艺术基金会名人堂。该基金会由纽约艺术理事会于 1971 年创建，主要向独立艺术家、作家提供资助，是全美知名的非营利艺术服务机构。
8 陈怡（1953— ），当代美籍华裔著名作曲家。

new milestones for Chinese music in the West as their jointly composed *Symphony Humen 1839*[1] was nominated for the Grammy Award for best orchestral performance.

9 Being temporal and malleable, music can be creatively and effectively adapted to whatever facet of the modern life that artists attempt to construct and negotiate at localized or globalized sites. Grasping such a nature of music, and learning from their ancestors, Chinese people employ historically and culturally rooted ideologies and practices to guide their musical discourse. Chinese music, they believe, is sonically expressing their Chinese self in a wider and broader stage.

temporal *adj.* 具有时间性的

malleable *adj.* （人、思想等）可塑的；易受影响（或改变）的

facet *n.* （问题、形势等的）方面；部分

(1043 words)

(From: Lam J. Chinese Music and Its Globalized Past and Present. *Macalester International*, 21.)

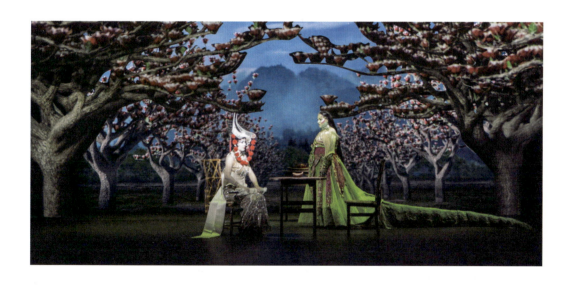

[1] 歌剧《虎门1839》，由美籍华裔作曲家周龙与陈怡夫妇受广州交响乐团委托联袂创作，新西兰交响乐团录音演出，发表于 2015 年。

Part I Understanding the Text

Task 1 Global Understanding

1. Read the text, and answer the following questions.

1) What are the new marketing methods to promote Chinese music?

2) Is it a good thing for Chinese instrumental music being globalized and brought to new homes around the world, and why?

3) What is the purpose of writing this text?

2. Match the correct headings to the paragraphs below.

Paragraph 3	Musical Features of Zhou Long
Paragraph 6	The New Sonority of Contemporary Chinese Music
Paragraph 7	The Unexpected Interaction Between Globalized Chinese Music and Chinese Image

Task 2 Detailed Understanding

1. Answer the following questions according to the text.

1) In what ways does globalization impact Chinese music?

2) What is the proper way to approach the now widely-globalized Chinese music?

3) What achievements has the Chinese composer Zhou Long made?

2. Discuss the following questions with your partner.

1) What is the better interpretation of the globalization of Chinese music?

2) Why do Chinese conservatories devote so many human and material resources to train Chinese musicians?

3) What is so special about Zhou Long's *Madame White Snake*?

Part II Building Language

Task 1 Key Terms

The words or phrases below are related to music. Discuss with your classmates and provide your understanding about each term in English.

1) sonority: _____

2) ensemble: _____

3) blues: _____

4) zydeco: _____

5) conductor: _____

6) orchestra: _____

7) pitch: _____

8) slide: _____

9) B minor: _____

10) opera: _____

Task 2 Vocabulary

Match the definitions on the right with the words on the left.

1) quintessential A deserving great praise

2) hybrid B the form of a language that a particular group of speakers use naturally, especially in informal situations

3) homogenize C to fix sth. firmly into a substance

4) meritorious D being the most typical example or most important part of sth.

5) vernacular E to cause sth. to continue

6) malleable F sth. that is a mixture of two very different things

7) perpetuate G easily influenced, trained or controlled

8) embed H to change sth. so that all its parts or features become the same or very similar

9) enshrine I to show sth. clearly, through sings or actions

10) consolidate J possibly true; able to be believed

11) rigorous K to contain or keep sth. in a place that is highly admired and respected

12) intrinsic L to respect someone or have a good opinion of them

13) plausible M to become, or cause sth. to become stronger and more certain

14) manifest N careful to look at or consider every part of sth. to make certain it is correct or safe

15) esteem O being an extremely important and basic characteristic of a person or thing

Part III Translation

1. Translate the following sentences into Chinese.

1) Anyone who has stayed in China for extended periods and engaged in substantial ways with her people, sounds, and sights will have experienced the phenomenon and noticed how its diverse elements interact and coordinate in their own ways.

2) Such sound effect can now be found in some modern performances of *Kunqu*, one of the most classical forms among Chinese operas.

3) In fact, contemporary Chinese instrumental music would not have become so prevalent if it was not supported by all kinds of Chinese music practitioners and audiences.

4) Often is the case that immigrant Chinese musicians collaborate with local and non-Chinese artists, creating music that fuses diverse genres and styles, ranging from blues to zydeco.

5) Being temporal and malleable, music can be creatively and effectively adapted to whatever facet of the modern life that artists attempt to construct and negotiate at localized or globalized sites.

2. Translate the following sentences into English.

1) 在神圣洁净的乐声中,人们的精神能即刻获得修补。当人们走出音乐厅时,他们重振精神,不再是一群疲惫的可怜人。

2) 从"道法自然""天人合一"的发展理念,到"同舟共济""休戚与共"的命运共同体意识,这些由中华优秀传统文化不断滋养润泽的道德品质,在世界各地激起更多共鸣。

3) 有证据表明,扬琴最早出现在明朝的东南省份,这表明该乐器是从中东通过海路传播而来,而非通过传统的陆上丝绸之路传播而来。

4) 古筝是一种中国传统弹拨乐器,在其漫长的历史中经历了许多变化。至今发现的最古老的古筝有 13 根弦,其年代可能是在战国时期(公元前 475—公元前 221 年)。

5) 中华文化积淀着中华民族最深沉的精神追求,是中华民族生生不息、发展壮大的丰厚营养。

Writing Skills

Writing an Opinion Essay

Part I Preparation

Task 1 Introduction

An opinion essay is a formal piece of writing that presents the author's point of view on a particular subject supported by reasoning and examples. The main purpose of the opinion essay is to:

- prove some ideas;
- give your opinion on a specific topic;
- explain something from the subjective position of a writer;
- describe the causes and relationship of something from the writer's perspective.

Just like any other paper, an opinion essay starts with an introduction, has several points in the body part, and concludes with a high-level overview of the presented ideas.

Task 2 Preparation Task

The following is an example of an opinion essay. Fill in the blanks with appropriate words or phrases given in the box.

| dynamics | gravity | for this purpose | confront | identify | accounts for |

To 1) _____ cyberbullying effectively, it is vital to know how to 2) _____ what it is and spread this awareness among the children who may unwarily become participants. The tendency to raise this issue in the scientific and public

spheres has positive 3) _____. As there is legal protection for cyberbullying victims in many countries, it is vital to detect harassment cases. 4) _____, parents and teachers should cooperate to create trustworthy relationships so the child can ask for help from adults. That 5) _____ why a high level of emotional support from parents and peers is of vital 6) _____ to combat bullying before it has occurred.

Part II Reading Example

Racial Problems in U.S. Arts Community

The United States is a multinational and multicultural country that is advanced in many areas, including healthcare, medicine, and science in general. However, some of the field studies show that the country is still in the process of overcoming racial segregation and inequality in its arts community.

Over the past years, American popular culture has been strong in creating racial stereotypes. Images displayed through television, music, and the internet have an impact on how individuals behave and what individuals believe. People find their identities and belief systems from popular culture. Analyzing the history of America reveals that African Americans have always had a problem defining themselves as Americans ever since the era of slavery. African Americans have always had a hard time being integrated into American culture. The result is that African Americans have been subjected to ridicule and shame. American pop culture has compounded the problem by enhancing the negative stereotypes of African Americans. In theater, film, and music, African Americans have been associated with vices such as murder, theft, and violence.

Moreover, the entire music-education system rests upon the outdated assumption that the Western tonality, with its major-minor harmony and its equal-tempered scale, is the master language. Vast tracts of the world's music, from West African talking drums to Indonesian gamelan[1], fall outside that system, and African-American traditions have played in its interstices. This is a reality that the music department at Harvard, once stiflingly conservative, has recognized. The Harvard musicologist Anne Shreffler has said of the new undergraduate music curriculum, "We relied on students showing up on our doorstep having had piano lessons since the age of six." Given the systemic inequality

1 佳美兰（亦称"甘美兰"），印度尼西亚历史最悠久的一种民族音乐，又以巴厘岛及爪哇岛的佳美兰合奏最为著名。弹奏该音乐主要的乐器有钢片琴类、木琴类、鼓、锣、竹笛、拨弦及拉弦乐器。

into which many people of color are born, this "class-based implicit requirement", as Shreffler calls it, becomes a covert form of racial exclusion.

Therefore, it is important to note that artists and authorities in the United States must acknowledge such systemic racism while also giving new weight to artists and musicians from other races and cultures. After all, music or any form of arts is not a weapon of division, but one for unity and love.

Tips

- Introduce your essay by restating the question in your own words.
- If the essay asks you as to "to what extent do you agree", make your opinion clear throughout. You can either agree, partially agree or disagree with the statement explaining and justifying your opinion.
- The structure should be:
 ✓ introduction;
 ✓ the first reason why you agree/disagree;
 ✓ the second reason why you agree/disagree;
 ✓ the third reason why you agree/disagree (if you have one);
 ✓ conclusion.
- Use phrases to organize and link your ideas (e.g. *Owing to…, One justification for…, The first thing to consider is…, A further reason…, In conclusion…*).
- If you do not have solid evidence for your ideas, use modal verbs such as *might, may* or *could* (e.g. *they could develop more empathy and care*) or other tentative phrases (e.g. *it does not appear to be an effective punishment*).
- Conclude by restating your opinion and summarizing your two or three main arguments.

Part III Task

What is a better way to protect traditional and folk culture? Is it better to retain its most authentic and original forms, or to marketize it so as to attract the most possible audience? Please write an essay in about 200 words and state your opinion concerning the above questions.

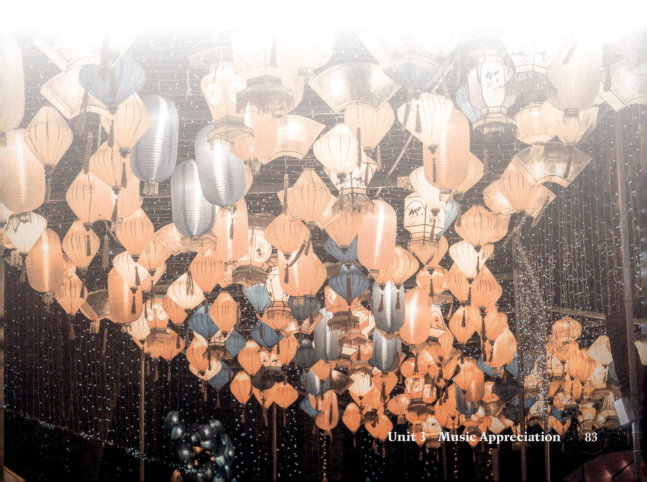

Learning Objectives

Students will be able to:
- understand the vocabulary of ballet;
- describe the characteristics of ballet;
- understand the styles of ballet;
- gain an appreciation of ballet;
- write an explanation.

The Art of Ballet

Unit 4

Lead-In

Task 1 Exploring the Theme

Look at the pictures and answer the questions.

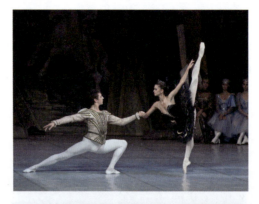

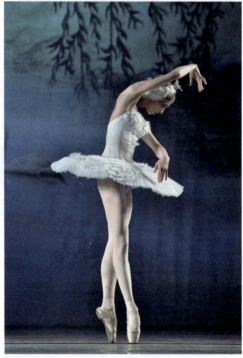

1) What kind of dance do they perform?

2) Why is this kind of dance so popular across the world?

Task 2 Brainstorming

Answer the following questions. Discuss with your classmates and share your answers with the class.

1) What is ballet?

2) Can you name any ballets known worldwide?

Task 3 Building Vocabulary

Talk with your classmates, and try to describe the following words and phrases in English.

> choreograph décor premiere artistry *Soaring Wings*

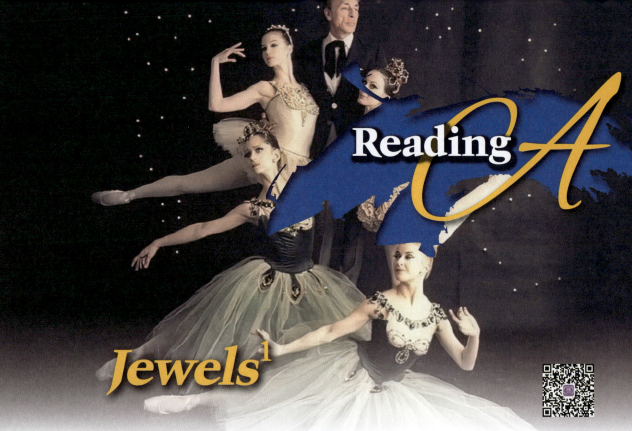

Reading A

Jewels[1]

choreograph v. 为（芭蕾舞或表演）设计舞蹈动作；编舞

brilliantly adv. 精彩绝伦；光彩夺目地

imbue v. 使充满；灌输

propulsive adj. 有推进力的；推进的

evoke v. 唤起；引起（感情、记忆或形象）

1　In **choreographing** *Jewels*' three separate but united ballets, Balanchine[2] absorbed and **brilliantly** interpreted three diverse musical styles, the threads of narrative and atmosphere that clung to the music, and the sparkle and gleam of jewels that he saw on a visit to the Van Cleef & Arpels[3] store on 5th Avenue.

2　The ballets that make up *Jewels* also hint the national styles that **imbue** their music. *Rubies*[4] may be set to music by a Russian, Igor Stravinsky[5], but it has the **propulsive** speed, athletic zest, and swinging hips of American jazz. *Diamonds*[6], with its Tchaikovsky[7] music, **evokes** the world of Russian ballet in which Balanchine (like Stravinsky) was born.

3　*Emeralds*[8] is the first ballet of the evening, performed

1　芭蕾舞《珠宝》，由《红宝石》《绿宝石》和《钻石》三部分组成。
2　巴兰钦，美国芭蕾舞编导、演员。
3　梵克雅宝，来自法国的百年传奇珠宝品牌。
4　芭蕾舞《红宝石》。
5　伊戈尔·斯特拉文斯基，俄国作曲家。
6　芭蕾舞《钻石》。
7　柴可夫斯基，俄国作曲家。
8　芭蕾舞《绿宝石》。

in French. It is set on selections from the impressionistic **incidental** music that Gabriel Fauré[1] composed to accompany Maurice Maeterlinck's[2] play, *Pelléas et Mélisande*[3], plus additional selections from the music he created to **embellish** Edmond Haraucourt's[4] play *Shylock*[5].

4 The two plays' themes of love—its mysteries, its struggles, and its betrayals—drift lightly via the music into the choreography, and into its **décor**. As in all three ballets, Peter Harvey's set design involves variously suspended arrays of **ersatz** gems that **quiver** and twinkle in Mark Stanley's lighting. But for *Emeralds*, these hang in front of cloudy greenery, a forest so **impressionistically** rendered that it's barely recognizable as such.

5 This magical green world is inhabited by a **bevy** of **nymphs**, a **sprightly threesome**, and two princesses and their **cavaliers**. The leading dancers' costumes are almost identical to those of all the other women; only the quantity of jewels sewn onto their bodices reveal their status. They might just have wandered away from their friends for a **tryst** or to be alone, wending—with or without their lovers—through avenues formed by the ensemble of women.

6 This solo, for me, is one of *Emeralds*' brightest gems. Left alone on stage, with music swirling around her, Bouder stands and plays softly in the air with her hands, as if acknowledging breeze-stirred foliage; **revolving** on pointe, she bends toward surrounding grass or water. She **ripples** her arms, briefly lifts her skirts as if to wade. But even as Bouder takes off, steps into **arabesques**, springs into the air, and **exults** in having the space to herself, this choreography is as changeable as the wind.

7 The solo danced by Sara Mearns of Fauré's *Sicilienne*[6] is

1 加布里埃尔·福雷，法国作曲家。
2 莫里斯·梅特林克，比利时诗人、剧作家、散文家，诺贝尔文学奖获得者。
3 歌剧《佩利亚与梅丽桑》。
4 埃德蒙·哈拉库特，法国作家。
5 戏剧《夏洛克》。
6 乐曲《西西里舞曲》。

calmer, more introspective, and she gives it a quality both luscious and pensive. Her duet with Jonathan Stafford of the *Nocturne* from *Shylock* builds on these qualities; they enter together walking dreamily—she on pointe—like two lovers who understand each other. Balanchine gives them some glinting little accents too; once, they lift their arms in several tiny jerks; later she raises one leg the same way.

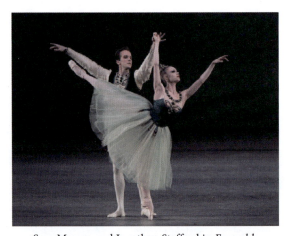

Sara Mearns and Jonathan Stafford in *Emeralds*

8 Mearns's solo and the duet are separated by a lively pas de trois[1]. I scribbled "facets" on my program, suddenly realizing that not only does Balanchine refer to the faceted surface of jewels in his symmetrical ensemble designs, but he also twists the movements themselves in order to display their facets.

9 *Emeralds* seems to happen in a dream world, however energetic the dancing gets. This seems especially true in the beautiful pas de sept[2] that Balanchine added after the premiere of *Jewels*. The two principal couples and the trio begin to wander, each dancer on a solitary track before they chain or cluster slowly in elegiac patterns. In the final moments, the four women drift away, and the three men drop to one knee, all facing the same diagonal and reaching toward a distance beyond the stage.

1 三人舞。
2 七人舞。

10 There's nothing dreamlike about *Rubies*. When pianist Susan Walters and the New York City Ballet Orchestra tear into Stravinsky's *Capriccio for Piano and Orchestra*[1], a small army is ready for it, ranged in four units of one man and two women. They're wearing shiny red outfits—tunics for the men and very short skirts for the women that are separated into flame-like strips. The trios surround a tall, slender leader, Teresa Reichlen. She sets the tone; like her, all the women swing their hips forward, but only the marvelous Reichlen has legs so long that when she slings one insouciantly into the air behind her, you imagine it could knock down any opponent.

tunics n. （古希腊、古罗马时期及膝的）短袍

marvelous adj. 不可思议的；了不起的

insouciantly adv. 漫不经心地；漠不关心地

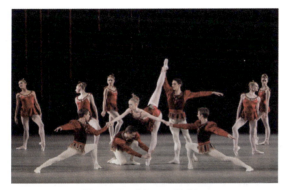

Teresa Reichlen in *Rubies*

11 Many of the ensemble dancers in *Rubies*, along with the other principals, Megan Fairchild and Joaquin De Luz, are considerably smaller than Reichlen. Their feet are flexed as often as they're pointed, and a little shimmying exchange acknowledges them as fond sparring partners.

12 At moments, the piano behaves like a cimbalom, giving a gypsy undertone to the jazzy athletics. The women unreel chains of piqué turns[2]; the men show how high they can jump. Fast! Hot! That's rubies for you.

13 *Diamonds* utilizes all but the first of the five movements that make up Tchaikovsky's *Symphony No. 3 in D Major*[3]. As

shimmy v. （抖动着肩膀和臀部）跳希米舞；一扭一摆地走

cimbalom n. 钦巴龙扬琴；（尤指）匈牙利扬琴

gypsy n. 吉普赛人

undertone n. 蕴涵的感情（或特质、意思）；寓意；弦外之音

1　《钢琴与管弦乐随想曲》。
2　蜂刺式旋转。
3　《D 大调第三交响曲》。

is proper for a closer, this ballet has more dancers in it than *Jewels*' two preceding works. Beneath glittering stones bunched into shapes resembling chandeliers, twelve women in white knee-length tutus dance. Partners eventually turn up for all of them. Four women higher in status at this musical court have men equal to them in rank. But the prince and princess rendezvous alone, slowly walking toward each other to the mournful melody played by a solo bassoon.

14 This long duet to the Andante Elegiaco[1], like several other Balanchine duets to Tchaikovsky's adagio music, seems to hint at a theme of 19th-century ballets laid in fairytale kingdoms. The man is subservient, yet supportive, and enamored of a remarkable and beautiful female, while she—fond enough of him to swoon backward into his arms—keeps looking and reaching into the distance, as if compelled by some other forces, some other yearning. These two people do, however, leave together.

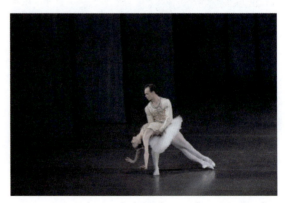

Maria Kowroski caught by Tyler Angle in *Diamonds*

15 At the first performance of *Jewels* this season, these roles were taken by Maria Kowroski and Tyler Angle. Kowroski combines a certain reticence with the large-scale dancing that her height emphasizes so thrillingly. Sometimes her mind seems elsewhere instead of on Angle. But he is the true prince of a partner. He doesn't just help her to do what she couldn't manage alone; he brings warmth and an unwavering focus on

1 行板挽歌。

his task.

16 Despite its beauty, I find *Diamonds* less **enthralling** than *Emeralds* and *Rubies*. By the end of it, with its **polonaise** and its rushing, its changing crowd patterns, you seem less to be watching diamonds form, dissolve, and reform than a snowstorm ordered by a master.

17 The living jewels of the evening are, of course, the performers who inherited their roles from dancers Balanchine adored and whose facets he was never tired of exploring.

(1117 words)

(From DanceBeat website, by Deborah Jowitt.)

enthralling *adj.* 迷人的；吸引人的

polonaise *n.* 波洛内兹舞（源于波兰的慢步舞）；波洛内兹舞曲

Part I Understanding the Text

Task 1 Global Understanding

1. Read the text, and identify the main ideas.

1) According to the text, what are the three ballets which constitute *Jewels*?

2) Can you write down some key information in each ballet?

 Ballet 1: _____

 Ballet 2: _____

 Ballet 3: _____

2. Read the text and decide whether the following sentences are true (T) or false (F).

() 1) In choreographing *Jewels*, Balanchine absorbed and interpreted three diverse musical styles.

() 2) In *Emeralds*, the leading dancers' costumes are different from other dancers.

() 3) The ballet *Diamonds* has fewer dancers in it than *Jewels*' two preceding works.

() 4) The author thinks that *Diamonds* is more attractive than *Emeralds* and *Rubies*.

() 5) *Jewels* begins with *Emeralds*, then *Rubies* and *Diamonds* is the last one.

Task 2 Detailed Understanding

1. Read the text again and choose the best answer to each question below.

1) In the ballet *Emeralds*, the music is created by _____.

 A. Balanchine

 B. Maurice Maeterlinck

 C. Edmond Haraucourt

 D. Gabriel Fauré

2) How to reveal dancers' status in the ballet *Emeralds*?

 A. By costumes.

 B. By the quantity of jewels.

 C. By the roles they play.

 D. By the order they come to the stage.

3) Why do the living jewels of the evening refer to the performers?

 A. Because they wear fancy costumes.

 B. Because they look like jewels.

 C. Because they inherited their roles from dancers Balanchine adored.

 D. Because they are full of energy.

2. Answer the following questions according to the text.

1) What are the three diverse styles of music used by Balanchine in *Jewels*?

2) Why is Angle the true prince of a partner?

3) Why does the author believe *Diamonds* is less fascinating than *Emeralds* and *Rubies*?

Part II Building Language

Task 1 Key Terms

The words or phrases below are related to ballet. Discuss with your classmates and provide your understanding about each term in English.

1) ballet: _____

2) choreograph: _____

3) duet: _____

4) pas de trois: _____

5) revolve: _____

6) shimmy: _____

7) premiere: _____

8) solo: _____

9) ensemble: _____

10) pointe: _____

Task 2 Vocabulary

Choose the correct word or phrase from the box below to complete each of the following sentences. Change the form where necessary.

imbue	embellish	sprightly	introspective	marvelous
evoke	render	enthralling	incidental	subservient
exult	rendezvous	revolve	reticence	acknowledge

1) The performance of singing and dancing were _____ with Chinese national characteristics.

2) Pieces of fine art may _____ emotional or spiritual responses in us.

3) The playing of music proved to be _____ to the main business of the evening.

4) _____ with red plum blossoms, the garden looked even more beautiful after the snow.

5) Some banks have begun to _____ such new services as issuing guarantees and witness in favor of the foreign investments.

6) _____ and bearded, he completed a half marathon at the weekend in 5 hours.

7) Of course, we now know that the planets, including the Earth, _____ around the Sun, and that the solar system is only a tiny part of the universe.

8) Stand proudly and _____ in your womanhood. Remember: women hold up half the sky.

9) The more active resting female brain may explain their reported ability to multi-task and be more _____ than men.

10) Like animals, plants also experienced complex and _____ evolutionary history.

11) They _____ that, in a few cases, home schooling offers educational opportunities superior to those found in most public schools, but few parents can provide such educational advantages.

12) She wondered where they were going to _____ afterwards.

13) The needs of individuals were _____ to those of the group as a whole.

14) Her _____ was in sharp contrast to the glamour and star status of her predecessors.

15) Genial sunshine, gentle breeze, mountains and forests all tinged, the world presents a(n) _____ view of autumn, which can not only be seen and listened, but also be tasted and felt.

Part III Translation

1. Translate the following sentences into Chinese.

1) In choreographing *Jewels*' three separate but united ballets, Balanchine absorbed and brilliantly interpreted three diverse musical styles.

2) The ballets that make up *Jewels* also hint the national styles that imbue their music.

3) The leading dancers' costumes are almost identical to those of all the other women; only the quantity of jewels sewn onto their bodices reveal their status.

4) Not only does Balanchine refer to the faceted surface of jewels in his symmetrical ensemble designs, but he also twists the movements themselves in order to display their facets.

5) The living jewels of the evening are, of course, the performers who inherited their roles from dancers Balanchine adored and whose facets he was never tired of exploring.

2. Translate the following sentences into English.

1) 芭蕾舞是一种欧洲古典舞蹈,用音乐、舞蹈来表演戏剧情节。

2) 芭蕾舞最重要的一个特征是女演员表演时以脚尖点地,故又称脚尖舞。

3) 西方评论界盛赞巴兰钦为"20 世纪最富有创造活力的芭蕾编导家之一"。

4) 芭蕾舞被称为舞蹈艺术皇冠上的明珠,它有着复杂的结构形式和特定的技巧要求。

5) 经典芭蕾舞剧《天鹅湖》具有非凡的艺术价值。

Reading B

Soaring Wings[1]

China's Swan Lake ballet experiences *sensational* success in New York.

sensational *adj.* 轰动的；绝妙的

Performers dance drama *Soaring Wings* at Lincoln Center in New York

1 New York City, a city of world culture, is never short of **top-level** art performances. New Yorkers have the **pickiest** ears, eyes and tastes for art. The Chinese dance drama *Soaring Wings*:

top-level *adj.* 最高级别的；最优秀的

picky *adj.* 挑剔的；难伺候的

1 中国芭蕾舞剧《朱鹮》。

Journey of the Crested Ibis premiered at the David H. Koch Theater[1] in New York City's Lincoln Center[2]. It is produced by Shanghai Dance Theater, exploring the fate of crested ibises, beautiful and rare creatures that symbolize happiness and blessings in ancient China. Following modernization and urbanization, the living environment for crested ibises began to deteriorate and in the middle of the 20th century, making them the endangered species. This ballet won the hearts of New Yorkers with its elegant cultural atmosphere from China.

Oriental Charm

2 It is quite rare that a dance drama from another country can attract such a big audience. The audience not only stood and applauded for a long time after the performance, but also waited in a long line to take photos with the principal dancers and asked for their autographs.

3 "This is undoubtedly a top-level dance show," said Jane Lim, a Chinese American lady who took her 10-year-old daughter to the play. "My daughter has practiced ballet for five years. I am so glad that she can watch such a high-level dance performance tonight. And I think she can also feel the beauty of Chinese culture from other elements of the play," she told *Beijing Review*[3].

4 With traditional Chinese music, opulent costumes and expressive choreography, *Soaring Wings* is a dance drama about crested ibises, beautiful, precious and rare creatures, which symbolize happiness and blessings. The drama, which focuses on the importance of keeping a harmonious relationship with animals and reflects the interdependence between human beings and nature, actually is a history of the species.

5 The drama pictured a harmonious coexistence during the

1 大卫·科赫剧院。
2 林肯中心。
3 《北京周报》。

agrarian *adj.* 农业的；耕地的

reserved *adj.* 寡言少语的；矜持的

vulnerable *adj.* 脆弱的；（身体上或感情上）易受……伤害的

occasionally *adv.* 偶尔地；偶然

extinction *n.* 灭绝；（植物、动物、生活方式等的）绝种

agrarian age in the beginning. Centuries ago, human beings lived in harmony with these birds—reserved, elegant, sacred and noble, yet also sensitive, vulnerable and occasionally distant. They once were on the edge of extinction due to the destruction of their environment in the industrial age. Fortunately, people discovered the last seven birds in 1981, carried out protection plans for them, and made great achievements to save this precious creature by protecting the environment.

6 "Elegant!" said a man in his 50s who gave his name as David. "That is the only word I can think of right now to describe the drama." He stressed that the dance part was wonderful. However, what touched him most were all the details: costumes, stage design and music. "I saw how Chinese people lived their lives in ancient times. As those girls walked on the stage, I felt I really saw a group of birds at that moment," he added. "It is quite different to the ballet dance that we are familiar with, but it is also extremely beautiful with its oriental charm."

A Feast of Chinese Arts

7 With a perfect combination of classic ballet and traditional Chinese folk dance, a stage design based on Chinese ink and wash painting, and a background of Chinese folk music, *Soaring Wings* indeed is a feast of Chinese arts cooked up by the Shanghai Dance Theater. Since its premiere on October 7, 2014, *Soaring Wings* has been honored to receive many awards in China.

8 Chen Feihua, director of *Soaring Wings*, said that his team had made great efforts on the costume design. "As the audience can see, performers wear two sets of costumes of the bird. Their major costume color is the pinky white of the crested ibis, their skirt is shaped like the body of the bird, and their ballet shoes are specially made with a red tip, which is exactly like the bird's feet," he explained. When performers play the part describing how the crested ibis died due to the polluted environment, they

wear the other costume in the color of ink, giving the audience a direct experience of pollution.

9 *Soaring Wings* has played nearly 200 performances in China and other Asian countries. This was the first time that it performed outside Asia. Performers of *Soaring Wings*, Zhu Jiejing and Wang Jiajun, both principal dancers of the Shanghai Dance Theater, were very excited about their **debut** at the Lincoln Center.

debut *n.* 初次登台（或上场）；首演

10 "Performing at the Lincoln Center is the dream of a dancer like me," said Wang. "It is of special significance to us to perform here at the beginning of 2018." He **remarked** that the reaction of the audience was beyond their expectations. "We had performed in Japan before, and Japanese audiences were very enthusiastic about the show because the crested ibis is Japan's national bird," he explained.

remark *v.* 评论；说起

11 Zhu Jiejing said she believes dance is an art that can act as a bridge between people with no need of language. "*Soaring Wings* shows the importance of keeping a harmonious relationship with animals and reflects the interdependence between human beings and nature. Actually, people of different backgrounds and nationalities also need to peacefully coexist in this world. New York City is a city of cultural **diversity**. I hope the crested ibis, the bird of good fortune, can bring them peace and friendship as well."

diversity *n.* 差异（性）；多样化

12 *Soaring Wings* is a part of "Image China", a cultural exchange **initiative** of China Arts and Entertainment Group (CAEG)[1]. "Nature has always been an **integral** part of Chinese culture and philosophy, and we tend to focus on the relationships between the various elements in nature, rather than what controls them," said Wang Xiuqin, deputy director of CAEG.

initiative *n.* 倡议；主动性

integral *adj.* 完整的；不可或缺的

13 "We hope that this dance drama, performed with **artistry** and **grace** by the Shanghai Dance Theater, will engage the hearts

artistry *n.* 艺术性；艺术技巧

grace *n.* 优美；优雅

1 中国对外文化集团有限公司。

Unit 4　The Art of Ballet

bring ... to life 起死回生

exhilarating *adj.* 令人兴奋的；令人激动的

inception *n.* （机构、组织等的）开端；创始

venue *n.* （事件或活动的）举办地点；场地

and minds of audience and bring the story of these beautiful creatures to life in unexpected and exhilarating ways," Wang told *Beijing Review*.

14 CAEG seeks to introduce traditional and contemporary Chinese performing arts to audiences around the world. Since its inception in 2009, Image China has presented works at performance venues across the globe, including the Lincoln Center in New York City, the Kennedy Center in Washington, D.C., and stages throughout Europe and Australia. Recent productions include *Confucius*[1], *Dragon Boat Racing*[2], *The Legend of Mulan*[3] and the acclaimed American debut of Peking Opera star Zhang Huoding[4].

(1039 words)

(From *Beijing Review* website.)

1 《孔子》。
2 《赛龙舟》。
3 《花木兰传奇》。
4 张火丁，京剧演员。

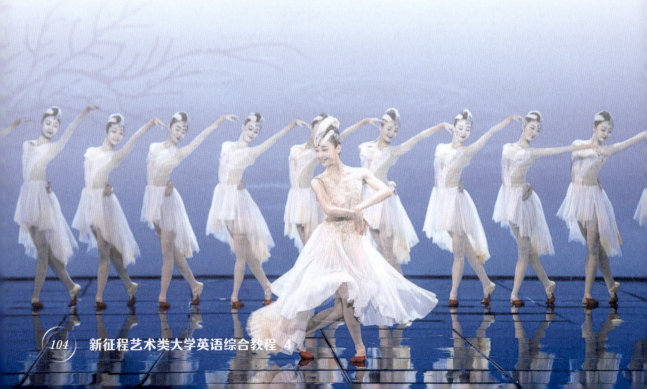

Part I Understanding the Text

Task 1 Global Understanding

1. Read the text, and identify the main ideas.

1) What does the dance drama *Soaring Wings* mainly tell us?

2) Talk with your classmates and discuss the characteristics of *Soaring Wings*.

2. Write down the key idea of each paragraph below.

Paragraph 1: _____

Paragraph 2: _____

Paragraph 3: _____

Task 2 Detailed Understanding

1. Answer the following questions according to the text.

1) In China, what do crested ibises symbolize?

2) What is the factor that leads to crested ibises on the edge of extinction?

3) What does CAEG (China Arts and Entertainment Group) seek to do?

2. Discuss the following questions with your partner.

1) How do you understand "an art can act as a bridge between people with no need of language" in Paragraph 11?

2) What does Shanghai Dance Theater expect to achieve through the performance of *Soaring Wings*?

3) Why is the ballet *Soaring Wings* well acclaimed in many countries?

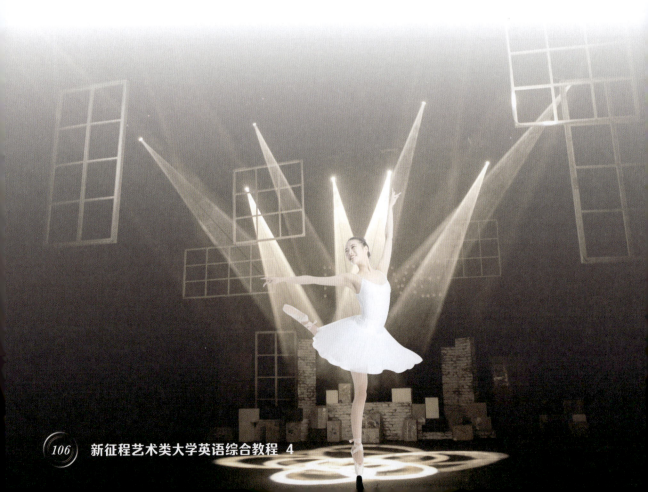

Part II Building Language

Task 1 Key Terms

The words or phrases below are related to ballet. Discuss with your classmates and provide your understanding about each term in English.

1) dance drama: _____

2) elegant: _____

3) principal: _____

4) choreography: _____

5) classic: _____

6) folk dance: _____

7) costume: _____

8) debut: _____

9) artistry: _____

10) grace: _____

Task 2 Vocabulary

Choose the correct word or phrase from the box below to complete each of the following sentences. Change the form where necessary.

opulent	integral	occasionally	urbanization	sensational
remark	deteriorate	autograph	focus	inception
agrarian	initiative	exhilarating	vulnerable	reserved

1) Both the public and the scientific community have often been misled by widespread dissemination of _____ but weakly founded hypotheses.

2) As a recently published paper shows, the process of _____ will only accelerate in the decades to come—with an enormous impact on biodiversity and potentially on climate change.

3) Paintings must have rigid stretchers so that the canvas will be taut, and the paint must not _____, crack, or discolor.

4) Rock stars have to get used to being plagued by _____ hunters.

5) The gorgeous Georgina Chapman churned out a(n) _____ collection of both party frocks and dramatic gowns.

6) It took an extraordinary effort to _____ on preparing his classes or correcting his students' work.

7) Until recently, anthropologists believe that evolutionary pressure on humans eased after the transition to a more stable _____ lifestyle.

8) Mike was bouncy (活泼的) and ebullient (热情的) while Helen was diffident and _____.

9) Research has shown that children are more _____ to environmental pollution than adults.

10) She listened keenly, _____ breaking in with pertinent questions.

11) The judges _____ on the high standard of entries for the competition.

12) In this way they brought into full play the _____, wisdom and power of the masses.

13) Rituals, celebrations, and festivals form a(n) _____ part of every human society.

14) When your confidence is high, even a difficult challenge will seem fun and _____.

15) The _____ of cultural industry is a great significant event in modern social history of development.

Part III Translation

1. Translate the following sentences into Chinese.

1) This ballet won the hearts of New Yorkers with its elegant cultural atmosphere from China.

2) The audience not only stood and applauded for a long time after the performance, but also waited in a long line to take photos with the principal dancers and asked for their autographs.

3) With traditional Chinese music, opulent costumes and expressive choreography, *Soaring Wings* is a dance drama about crested ibises, beautiful, precious and rare creatures, which symbolize happiness and blessings.

4) With a perfect combination of classic ballet and traditional Chinese folk dance, a stage design based on Chinese ink and wash painting, and a background of Chinese folk music, *Soaring Wings* indeed is a feast of Chinese arts.

5) *Soaring Wings* shows the importance of keeping a harmonious relationship with animals and reflects the interdependence between human beings and nature.

2. Translate the following sentences into English.

1) 《红色娘子军》与《白毛女》在中国芭蕾舞剧发展史上具有里程碑式的意义。

2) 以中国文学、戏剧名著改编的芭蕾舞剧，成果显著。

3) 运用芭蕾特有的形式手段，表现中国人民特有的生活和情感世界，逐渐成为中国芭蕾一脉相承的创作共识。

4) 深化对现实生活的表现力度，已成为中国芭蕾创新的第一推动力。

5) 提倡运用芭蕾语汇讲述中国故事，诠释民族精神和中国气派。

Writing Skills

Writing an Explanation Letter

Part I Preparation

Task 1 Introduction

An explanation letter is written to explain a situation or a circumstance. This letter can be written by a client, an employee or a student to explain something being asked. This letter is addressed to a higher authority or relevant person inquiring about a situation or circumstance.

An explanation letter is important to inform the relevant party of the reason for the mistake, absence, negligence or incident that they are inquiring about. Such a letter can be used to clear miscommunication that could result from sudden or unclear circumstances.

Task 2 Preparation Task

The following is an example of an explanation letter. Fill in the blanks with appropriate words or phrases given in the box. Change the form when necessary.

| explanation | due to | reference | hereby | attach |
| apologize | kindly | aware | require | |

1) I _____ write this letter as a(n) _____ letter to my current financial situation.

2) I am dealing with a massive financial constraint _____ an accident that left me unable to work.

3) I _____ for not meeting the agreement of the contract to make a monthly contribution to my loan repayment.

4) _____ provide me with a temporary agreement to make minimal payments in the following three months.

5) You are _____ I have always met my loan payments monthly as _____.

6) Please see the _____ medical records on my health situation for your _____.

Part II Reading Example

Dear Sir,

 I want to put this letter as an explanation to your kind notice that presently I am dealing with massive financial crisis as I have lost my last job due to some specific reason. Right now, I am entirely jobless, and in this situation, I am helpless and unable to pay back the monthly EMI for the loan I had taken from your bank last year for my car. I am trying hard to get another job and make the situation healthy as soon as possible. But you know in this recession it is tough to get another job in a short period.

 It does not need anything to say as you know me very well, and I hope you can recognize that I have a very good history for my paying bills. I was never late in my payment. I will pay everything I owe, but now all I can ask for is a little bit cooperation with me so I can overcome the situation really soon.

 I hope this situation is temporary and won't last long in the future and I hope you to cooperate a bit so you can provide me with a plan with minimal payment or no payment for the next few months. I know you have some idea of repayment in your account. If you consider my problem and handle this with an iron hand, I will be really grateful.

 Thank you.

<div align="right">Yours sincerely
Vincent Cooper</div>

Tips

- Give precise details of the situation or circumstances.
- Describe the facts that resulted in the current situation.
- Be truthful so that you may not find yourself in a difficult position.
- Provide supporting documents if they are available.
- Describe what you will do to make the correction.
- Keep it direct to the point.

Part III Task

Write a paragraph in no more than 300 words to explain the reasons for your overdue payment for your monthly loan.

Learning Objectives

Students will be able to:

- understand the vocabulary of film reviews;
- appreciate Western famous films;
- understand the vocabulary of different genres of films;
- gain an appreciation of Hong Kong films;
- write a report on a research study.

Unit 5

Film and Pop Culture

Lead-In

Task 1 Exploring the Theme

Listen to a passage about Steven Spielberg and fill in the blanks.

1) Steven Spielberg is a prolific (多产的) and super-successful American film director and producer. He has won three Best Movie Oscars, among hundreds of other awards. His movies have made nearly $8 billion, the highest for any filmmaker in history. *Time* magazine _____ him as one of the 100 greatest people of the 20th century.

2) *Life* named him the most _____ person of his generation. Spielberg was born in Ohio in 1946. He was interested in movies when he was very young.

3) When he was 16, Spielberg filmed a 2-hour _____ epic. He set his sights on Hollywood.

4) Spielberg failed to get into film school because of his high school grades. He was undeterred and went directly to Universal Studios, where he got a position as an _____. In 1968, he made a short film that caught the attention of Universal's vice president.

5) Spielberg's first major movie was the shark horror film *Jaws*. It was a _____ hit and made Spielberg a household name.

6) He has since made many _____ that have become a part of world culture, including *Jurassic Park*, *Indiana Jones* and *E.T.*

7) Spielberg has also dealt with serious issues such as slavery, the Holocaust and _____.

8) He has also _____ into video game production.

Task 2 Brainstorming

Answer the following questions. Discuss with your classmates and share your answers with the class.

1) Which film director in Western countries are you familiar with? Please list some of their representative works.

2) How do you understand popular culture? Can you give a brief definition of popular culture?

Task 3 Building Vocabulary

Talk with your classmates, and try to describe the following words and phrases in English.

> science fiction adventure film socially awkward OASIS
> Ang Lee's film style China's Fifth Generation Directors

Reading A

Ready Player One[1] — A Love Letter to Pop Culture

1 As one of the most influential personalities in the history of cinema, Steven Spielberg[2] is Hollywood's best-known director and one of the wealthiest filmmakers in the world. He has an **extraordinary** number of **commercially** successful and critically **acclaimed credits** to his name, either as a director, a producer or a writer since **launching** the summer blockbuster *Jaws*[3] in 1975, and he has done more to define popular filmmaking since the mid-1970s than anyone else, including *E.T. the Extra-Terrestrial*[4], *Empire of the Sun*[5], *Jurassic Park*[6], *Schindler's List*[7], *A.I. Artificial Intelligence*[8], *War Horse*[9], etc.

2 *Ready Player One* is a science fiction adventure film directed by Steven Spielberg based on the bestselling novel

extraordinary *adj.* 不平常的；卓越的
commercially *adv.* 商业上地；商品化地
acclaimed *adj.* 受称赞的
credit *n.* （电影或电视节目的）摄制人员名单；信誉；声望
launch *v.* 推出；将……投放市场

1 电影《头号玩家》(2018)。
2 美国著名导演史蒂文·斯皮尔伯格（1946—　）。
3 电影《大白鲨》(1975)。
4 电影《E.T. 外星人》(1982)。
5 电影《太阳帝国》(1987)。
6 电影《侏罗纪公园》(1993)。
7 电影《辛德勒的名单》(1993)。
8 电影《人工智能》(2001)。
9 电影《战马》(2011)。

from Ernest Cline, who co-wrote the script with Zak Penn. It takes place in the future of Columbus, Ohio in the year 2047. We follow Wade Watts, who prefers to spend his days in the OASIS[1], a virtual reality universe created by a recently **deceased** genius, James Halliday who is a socially awkward scientist working for a company called Gregarious Games.

deceased *adj.* 已死的

3 The description above is just a peek into what the movie is! Imagine a world where technology is so advanced that people forget what is real and what is not. Think of the OASIS as a world created solely by your thoughts and actions. Think of it as Minecraft[2] in terms of the flexibility one gets when creating an alternate reality with them in it. Imagine a world that is fully **customizable** and the limits of reality are your own imagination. Imagine a "Quidditch"[3] match in outer space. Imagine a **casino** that is the size of a planet. Imagine skiing down the Pyramids. Imagine climbing Mt. Qomolangma with the Batman. Imagine having **portals** that can transfer you to other creations alike. You can create anything and go anywhere. People come to the OASIS for all the things they can do but stay for all the things they can be (tall, short, beautiful, different sex, a different species, a character from a cartoon/comic or someone from a live-action movie)!

customizable *adj.* 可定制的

casino *n.* 赌场

portal *n.* 入口；传送门

4 Halliday leaves behind three distinct challenges open to all the players in the OASIS. **Cracking** each challenge would give the player a magical key that would unlock the door and the clue to the next challenge. Find all three keys and you'll reach the end where the ultimate prize—Halliday's Golden Egg—awaits. The winner gets complete control of the OASIS and all of Halliday's holding shares in Gregarious Games which value up to half a trillion dollars.

crack *v.* 破译；破解

5 What follows is a visually stunning chain of events that span across different eras of pop culture **captivating** the audience as we go along the narrative. Spielberg is already the

captivate *v.* 使入迷；迷住

1 绿洲，电影《头号玩家》里的虚拟世界。
2 "我的世界"，一款沙盒类电子游戏。
3 "魁地奇"比赛，是"哈利·波特"系列电影中重要的空中团队对抗运动。

jaw-dropping *adj.* 令人惊愕的；令人震惊的

cutting-edge *adj.* 先进的；尖端的

sprawling *adj.* 庞大的；不规则伸展的

confine *v.* 把……局限在；限制

pay homage to 向……表示敬意；致敬

master creating giant breathtaking crafts that give the audience some jaw-dropping action sequences in the movie, more so because the audience is made to fantasize that they are inside the virtual reality the players are in. Combine that with the cutting-edge CGI and unlimited imagination, you receive a scale that is so huge and sprawling that it cannot be confined to the boundaries of realism.

6 *Ready Player One* pays homage to popular culture from various time periods, mainly the 1970s and 1980s but also extending to the current period; reviewers have identified over a hundred references with films, television shows, music, toys, video games, anime, and comics from these eras. The audience are thrilled to see characters they have always loved on the big screen.

7 Below are some of the pre-existing characters/scenes/moments that were present in the movie:

- *The Arkham Knight*[1]—Wade enters the Halliday Journals after winning the first challenge.
- *King Kong*[2] and the dinosaur chasing cars from *Jurassic park*.

resemble *v.* 类似于

trilogy *n.* （书籍、电影等的）三部曲；三部剧

- Wade's car in the OASIS resembles the DeLorean from the *Back to the Future*[3] trilogy.
- In the scene where Halliday and Morrow are discussing the date with Kira, Halliday's monitor shows that he is working on the building of Room 237 of *The Shining*[4].
- The thumbs-up sign from *The Iron Giant* when going under the Lava is a direct reference to *The Terminator*[5].
- The magnificent fight scene in the end refers to some of the biggest names in pop culture such as He-Man from *He-Man and the Masters of the Universe*[6], Teenage Mutant Ninja Turtles from the live-action version of the

1 动作冒险类游戏《蝙蝠侠：阿甘骑士》(2015)。
2 电影《金刚》(2005)。
3 电影《回到未来》三部曲(1985)。
4 电影《闪灵》(1980)。
5 电影《终结者》(1984)。
6 动画片《宇宙的巨人希曼》(1983)。

2014 film, Spawn and Batgirl, Joker and Harley Quinn from DC Comics, spartan soldiers from the video game *Halo* in their suits and the original RX-78-2 suit from the *Mobile Suit Gundam* anime.

8 *Ready Player One* has some major advantages over the book. The exposition is relatively bald, but once it's done, Spielberg can focus on the endless dynamism of a world where anything is possible. As Wade and others follow their quest through races, battles, and puzzles, they encounter a dizzying blur of visual references that act as "Hey, remember this?" in-jokes with the audience, including some major ones that weren't in the book. But the filmmakers also delve into Halliday's past and his wounded psyche, in a way that gradually becomes a little touching and tragic. The film also goes further than the book in laying out why Halliday's retreat into a fantasy world wasn't necessarily good for anyone—especially not for Halliday himself. No matter how validating the onscreen jokes are, they might be still a reminder of a man who found more emotional resonance in *Jurassic Park*'s T-Rex[1] than in a connection with a living human being.

9 *Ready Player One* also takes a peek into reclusive youth culture. Today, the Internet has given people the liberty to express their deepest emotions under the guise of a pseudonym or avatar account. Wade's avatar is Parzival[2] and he feels most comfortable when inhabiting that digital body and hiding his own inner trauma behind a virtual face. The same goes for every other character in the movie.

10 It is worth mentioning that Alan Sylvestri, who is the main composer for the film, composes one of his most exhilarating scores in years and is a major plus for the film. *Ready Player One* is enjoyably diverting and speaks to the younger generation in some way fun. Spielberg delivers a movie in a way that only Spielberg can use and it was an enjoyable ride at that.

(1029 words)

(From The Cultured Nerd website.)

exposition *n.* （理论、计划等的）解释；阐述
bald *adj.* 简单的；直白的
dynamism *n.* 精力；活力
dizzying *adj.* 使人晕眩的；使人头晕眼花的
in-joke *n.* 行内笑话
delve *v.* 探究；挖掘
retreat *n.* 逃避
validating *adj.* 确认的
resonance *n.* 引起共鸣的力量
reclusive *adj.* 隐遁的；孤寂的
guise *n.* 装束；外观；伪装
pseudonym *n.* 假名；笔名
inhabit *v.* 居住于；占据
trauma *n.* 创伤；外伤
exhilarating *adj.* 令人振奋的
diverting *adj.* 有趣的；快乐的

1 指电影《侏罗纪公园》里的霸王龙。
2 帕西发尔（亚瑟王传奇中寻找圣杯的英雄人物）。

Part I Understanding the Text

Task 1 Global Understanding

1. Read the text and decide whether the following sentences are true (T) or false (F).

(　　) 1) *Ready Player One* is a thriller film directed by Steven Spielberg.

(　　) 2) The OASIS is a virtual reality universe in which you can create anything and go anywhere.

(　　) 3) The audience are attracted by the events and made to fantasize that they are inside the virtual reality that the players are in.

(　　) 4) *Ready Player One* pays homage to popular culture in various time periods, mainly the 1920s.

(　　) 5) The film has some major advantages over the book and goes further in revealing the fact that Halliday's retreat into a virtual reality universe is not beneficial for him.

2. Write down the key idea of each paragraph below.

Paragraph 1: _____

Paragraph 2: _____

Paragraph 3: _____

Task 2 Detailed Understanding

1. Read the text again and choose the best answer to each question below.

1) Which film is NOT directed by Steven Spielberg?
　　A. *Schindler's List.*　　　　　　B. *Jurassic Park.*
　　C. *King Kong.*　　　　　　　　D. *War Horse.*

2) What does " pays homage to " in Paragraph 6 mean?

 A. hates to do
 B. is in honor of
 C. is no fan of
 D. is in charge of

3) Which description is NOT correct about the film *Ready Player One*?

 A. It is adapted from the bestselling novel by Ernest Cline.
 B. It presents lots of pre-existing characters which are popular on the big screen.
 C. It refers to reclusive youth culture and speaks to the younger generation in some way.
 D. It can be considered as a complete science fiction adventure film without touching and tragic plots.

2. Answer the following questions according to the text.

1) What is the meaning of "summer blockbuster" in Paragraph 1?

2) According to the text, what is the ultimate prize players can get from the game?

3) How do you understand the sentence in Paragraph 10 "Spielberg delivers a movie in a way that only Spielberg can use and it was an enjoyable ride at that."?

Part II Building Language

Task 1 Key Terms

The words or phrases below are related to film. Discuss with your classmates and provide your understanding about each term in English.

1) filmmaker: _____

2) script: _____

3) action sequence: _____

4) CGI: _____

5) reviewer: _____

6) anime: _____

7) DC comics: _____

8) scene: _____

9) live-action: _____

10) onscreen: _____

Task 2 Vocabulary

Choose the correct word or phrase from the box below to complete each of the following sentences. Change the form where necessary.

| launch | crack | captivate | resemble | exposition |
| dizzying | delve | retreat | inhabit | bald |

1) The new model will be _____ in July next year.

2) Tina had started to _____ into her father's distant past.

3) Marina closely _____ her sister.

4) After a year in this job I think I've got it _____!

5) The children were _____ by the interesting stories.

6) Aristotle was valued because of his clear _____ of rational thought.

7) The army was forced to _____ after suffering heavy losses.

8) A variety of seabirds and shorebirds _____ the islands for a long time, including the endangered brown pelican, least tern, and piping plover.

9) The _____ fact is that we don't need you any longer.

10) This film belts along with a(n) _____ number of twists and turns.

Part III: Translation

1. Translate the following sentences into Chinese.

1) As one of the most influential personalities in the history of cinema, Steven Spielberg is Hollywood's best-known director and one of the wealthiest filmmakers in the world.

2) Combine that with the cutting-edge CGI and unlimited imagination, you receive a scale that is so huge and sprawling that it cannot be confined to the boundaries of realism.

3) What follows is a visually stunning chain of events that span across different eras of pop culture captivating the audience as we go along the narrative.

4) The audience are thrilled to see characters they have always loved on the big screen.

5) The film also goes further than the book in laying out why Halliday's retreat into a fantasy world wasn't necessarily good for anyone—especially not for Halliday himself.

2. Translate the following sentences into English.

1) 这部电影的原著作者表示，中国科幻电影开启了壮丽的篇章。

2) 中国的功夫、神话、中医等越来越多地出现在世界电影的银幕中。

3) 迪士尼的真人电影《花木兰》改编自中国古诗，讲述了一个中国女孩乔装成男人，替父在战场作战的故事。

4) "龙"作为人类几千年的神话代表，在中西电影中的表达是截然不同的。

5) 当今电影科技迅速发展，西方电影对华语武侠片中的功夫元素有所借鉴与模仿。

Reading B

Chinese Film in the West

1 Since the mid-1980s, Chinese film has made a strong impact in the West (i.e., Europe, North America and Australia). Chinese films from the mainland, Hong Kong and Taiwan have won film awards at international film festivals such as Berlin, Cannes, Locarno, Montreal, Nantes, Pesaro, Rotterdam, Tokyo, Toronto, Turin, and Venice. Art films from the mainland and Taiwan, films of gangster, martial arts and comedy from Hong Kong were regularly screened in art-theater houses in the West. Some were successfully marketed by the commercial theater chains and earned huge profits, such as *Farewell My Concubine*[1] and *Eat Drink Man Woman*[2].

gangster *n.* 匪徒
martial art 武术

2 There is a long tradition of cultural exchange in film between China and the West. The Hollywood presence in Shanghai was a significant factor in the Chinese film market during the 1920s—1940s. In the mid-1990s, the mainland

1 电影《霸王别姬》(1993)。
2 电影《饮食男女》(1994)。

began to import "ten major foreign films" each year, most of them Hollywood titles, such as *The Fugitive*[1], *Forrest Gump*[2], and *Die Hard with a Vengeance*[3]. These dubbed foreign films (in Chinese soundtrack) enjoy popularity rarely obtained by the majority of domestic features.

3 In fact, many early Chinese filmmakers had the Western world in mind when they started business. *Zhuangzi Tests His Wife*[4], the first Hong Kong short feature, is reputedly also the first Chinese film ever to be exported to the West. Other silent titles, such as *Romance of a Fruit Peddler*[5] and *Song of China*[6], carried both Chinese and English subtitles, presumably for export purposes. *Romance of the Western Chamber*[7], the film adaptation of a classic Chinese drama, was given a promotional English title, *Way Down West*, to invoke the famous *Way Down East*[8] (directed by D. W. Griffith, 1920) among Shanghai audiences who were familiar with Western films. Translated in French as *La Rose de Pu-Chui*, *Romance of the Western Chamber* was screened in Paris from April 20 to June 3, 1928. The film was then concurrently with *Ben-Hur*[9] and a German film *Joyless Streets*[10].

4 The export of Chinese films to be screened in Chinese communities in Southeast Asian countries is a practice as old as the Chinese film industries. But the export of Chinese films to the English-speaking audiences in the West did not constitute a significant trend until the 1970s, when King Hu and Chang Che revived the martial arts film in Hong Kong and Taiwan.

soundtrack *n.* （电影的）声带、配音；电影音乐磁带

reputedly *adv.* 据说

subtitle *n.* （电影或电视上的）字幕
presumably *adv.* 很可能
promotional *adj.* 广告宣传的
invoke *v.* 唤起

concurrently *adv.* 兼；同时发生地

revive *v.* 使复苏

1 电影《亡命天涯》（1993）。
2 电影《阿甘正传》（1994）。
3 电影《虎胆龙威3》（1995）。
4 电影《庄子试妻》（1913）。
5 电影《劳工之爱情》（1922）。
6 电影《天伦》（1935）。
7 电影《西厢记》（1927）。
8 电影《一路向东》（1920）。
9 电影《宾虚》（1925）。
10 电影《悲情花街》（1922）。

Soon, Bruce Lee, who grew up in the U.S. and became a kungfu superstar in Hong Kong, enjoyed a worldwide reputation for his impressive performance in such titles as *Fist of Fury*[1] and *Enter the Dragon*[2]. After Lee's **untimely** death in 1973, his screen image as a kungfu master was taken over by another Hong Kong star, Jackie Chan. Chan made himself a more likeable screen idol by softening Lee's seriousness in fighting and blending comic elements into the genre. Chan's success in the West is best **exemplified** in his *Rumble in the Bronx*[3].

untimely *adj.* 过早的；不到时间的

exemplify *v.* 是……的典型（或典范、榜样）

5 Chan has helped to bring Western attention to another genre, the gangster film, which has long been the **staple** of the Hong Kong film industry. The most notable directors of this genre include John Woo, Ringo Lam and Tsui Hark. Hong Kong superstars like Jackie Chan, Chow Yun-Fat and Michelle Yeoh have fascinated the world with their thrilling performances. They have become popular figures in the West, and their photos regularly appear in Western fan magazines. So successful is the Hong Kong gangster film that the three major directors named above moved to the U.S. and started shooting Hollywood action films, such as *Hard Target*[4] and *Maximum Risk*[5]. These directors were soon joined by action Hong Kong superstars Chow Yun-Fat and Michelle Yeoh.

staple *n.* 主要产品；支柱产品

6 The traffic of film people to the West also occurred in Taiwan and the mainland. Ang Lee, who grew up in Taiwan and was trained in the U.S., made his directorial debut in Taiwan and won international acclaim with *The Wedding Banquet*[6] and *Eat Drink Man Woman*. He returned to the U.S. and directed *Sense and Sensibility*[7], which won a Golden Bear at the 1996 Berlin Film Festival. Joan Chen, a mainland actress who won

1 电影《精武门》(1972)。
2 电影《龙争虎斗》(1973)。
3 电影《红番区》(1995)。
4 电影《终极标靶》(1993)。
5 电影《硬闯百分百危险》(1996)。
6 电影《喜宴》(1993)。
7 电影《理智与情感》(1995)。

Best Actress Award at the 1980 Hollywood Film Awards, went to the U.S. and starred in *The Last Emperor*[1], the TV series *Twin Peaks*[2], and other titles. Another actress from *The Last Emperor*, Vivian Wu, who was born in Shanghai in 1969, went on to star in *The Joy Luck Club*[3] and *The Pillow Book*[4]. In addition, Jet Li, a mainland martial arts champion who became a superstar in Hong Kong, has also reportedly worked on Hollywood films such as *Black Mask*[5].

7 Parallel to the Western "discovery" of contemporary Chinese film talents, another kind of discovery of early Chinese films took place in the early 1980s. The China Film Archive[6] in Beijing cooperated with its European **counterparts** and organized several film **retrospectives**, **showcasing** Chinese films of the 1920s—1940s in Western Europe and North America. Some of the retrospectives have resulted in the publication of festival **catalogues** with detailed listings of film **synopses** and **biographic** entries. In the 1980s—1990s, Chinese films produced in the mainland, Hong Kong and Taiwan are regularly invited to participate in international film festivals, and many of them have won top prizes.

8 Apart from showcasing their films in the West, Chinese filmmakers also make co-productions with other countries. *The Kite*[7] is a children's fantasy film co-produced with France. *Red Cherry*[8], a co-production with Russia with Chinese and English subtitles, scored a **domestic** box-office record in the mainland. Other than co-productions with the West, Chinese directors occasionally made films outside the Chinese-speaking

counterpart *n.* 职位（或作用）相当的人
retrospective *n.* （艺术家作品）回顾展
showcase *v./n.* 展现
catalogue *n.* 目录
synopsis *n.* 提要
biographic *adj.* 传记的

domestic *adj.* 国内的

1 电影《末代皇帝》(1987)。
2 美剧《双峰》(1990)。
3 电影《喜福会》(1993)。
4 电影《枕边书》(1996)。
5 电影《黑侠》(1996)。
6 中国电影资料馆。
7 电影《风筝》(1958)。
8 电影《红樱桃》(1995)。

communities. As early as the 1930s, *Singing Lovers*[1] was produced by Grandview (Daguan) Film[2] based in San Francisco. Obviously, an exceptional case, *Singing Lovers* foreshadows an alternative mode of film production for Chinese filmmakers, especially those who left their homelands in the 1980s—1990s. For instance, Chen Kaige, **eminent** member of China's Fifth Generation, raised funds in the West to produce his **avant-garde film**, *Life on a String*[3]. Clara Law, who had **emigrated** with her screenwriter-director husband Eddie Fong from Hong Kong to Melbourne in the early 1990s, made *Floating Life*[4], Australia's first foreign-language **feature**. In numerous other less known cases, Chinese filmmakers overseas (e.g., Mabel Cheung and Peng Xiaolian) have made documentaries and short features in the West.

eminent *adj.* （尤指在某专业中）卓越的

avant-garde film 先锋电影

emigrate *v.* 移民

feature *n.* （电影的）正片；故事片

9 By the mid-1990s, it is clear that Chinese film, in addition to attaining a solid international reputation, has also gone **transnational** in filmmaking, film distribution and exhibition. Such a new international and transnational aspect of Chinese film is perfectly embodied in the figure of Zhang Yimou, a mainland director who has won a Golden Bear and a Golden Lion, as well as two Oscar **nominations** for Best Foreign Film. His films are regularly financed by investors from Taiwan of China, Hong Kong of China and Japan. In 1996, he was invited by an Italian producer to direct a film based on Puccini's *Turandot*[5].

transnational *adj.* 跨国的

nomination *n.* 提名

(1146 words)

(From: Xiao, Z. W. & Zhang, Y. J. (1998). *Encyclopedia of Chinese Films.* London: Routledge.)

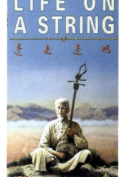

1 电影《歌侣情潮》(1933)。
2 大观声片有限公司。
3 电影《边走边唱》(1991)。
4 电影《浮生》(1996)。
5 歌剧《图兰朵》。

Part I Understanding the Text

Task 1 Global Understanding

1. Read the text, and identify the main ideas.

1) How do you understand the sentence "There is a long tradition of cultural exchange in film between China and the West" in Paragraph 2?

2) Talk with your classmates and discuss the development of the Hong Kong film industry.

2. Match the correct headings to the paragraphs below.

Paragraph 3 **A.** The Traffic of Film People to the West

Paragraph 4 **B.** The Export of Chinese Films to the West

Paragraph 5 **C.** Early Chinese Filmmakers and the West

Paragraph 6 **D.** The Co-production Between Chinese Filmmakers and the West

Paragraph 8 **E.** The Gangster Film and the West

Task 2 Detailed Understanding

1. Answer the following questions according to the text.

1) Why was the film *Romance of the Western Chamber* given the English title *Way Down West*?

2) Who revived the martial arts film in Hong Kong?

3) When are the Chinese films invited to participate in international film festivals?

2. Answer the following questions according to the text.

1) How do you understand "strong impact" in Paragraph 1?

2) What is the "avant-garde film" mentioned in Paragraph 8?

3) What are the differences between Western films in China and Chinese films in the West?

Part II Building Language

Task 1 Key Terms

The words or phrases below are related to film. Discuss with your classmates and provide your understanding about each term in English.

1) film festival: _____

2) art film: _____

3) gangster film: _____

4) martial arts film: _____

5) comedy film: _____

6) subtitle: _____

7) feature: _____

8) dubbed foreign film: _____

9) silent title: _____

10) soundtrack: _____

11) avant-garde film: _____

Task 2 Vocabulary

Match the definitions on the right with the words on the left.

1) reputedly A to be a typical example of sth.

2) presumably B an event that presents sb.'s abilities or the good qualities of sth. in an attractive way

3) concurrently C according to general belief or supposition

4) promotional D the first public appearance of a performer or sports player

5) exemplify E connected with advertising

6) showcase F used to say that you think that sth. is probably true

7) debut G overlapping in duration

8) eminent H famous and respected, especially in a particular profession

Part III Translation

1. Translate the following sentences into Chinese.

1) There is a long tradition of cultural exchange in film between China and the West.

2) These dubbed foreign films (in Chinese soundtrack) enjoy popularity rarely obtained by the majority of domestic features.

3) The export of Chinese films to be screened in Chinese communities in Southeast Asian countries is a practice as old as the Chinese film industries.

4) Parallel to the Western "discovery" of contemporary Chinese film talents, another kind of discovery of early Chinese films took place in the early 1980s.

5) Apart from showcasing their films in the West, Chinese filmmakers also make co-productions with other countries.

2. Translate the following sentences into English.

1) 《卧虎藏龙》的意义在于导演李安用恰当的方式让众多美国人理解和接受了中国元素。

2) 中国电影人应广泛开展国际合作,让中国电影走出去,将中国价值观和文化传播给全世界。

3) 电影类型分为剧情片、喜剧片、爱情片、奇幻片、科幻片以及西部片等。

4) 这是一部基于中国功夫的美国动作喜剧动画电影。

5) 建设文化强国,必须率先实现中国电影强国梦,这是电影人的历史使命和现实责任。

Writing Skills

Writing a Report on a Research Study

Part I Preparation

Task 1 Introduction

A research report is a reliable source to recount details about a conducted research and is most often considered to be a true testimony of all the work done to garner specificities of research. It usually contains summary, background/introduction, implemented methods, results based on analysis, deliberation and conclusion.

Task 2 Preparation Task

Match the definitions (A-H) with the vocabulary (1-8).

(　　) 1) employee turnover

(　　) 2) the principal objective

(　　) 3) a focus group

(　　) 4) engagement

(　　) 5) the participants

(　　) 6) the majority of those surveyed

(　　) 7) a correlation

(　　) 8) employee retention

A. a small group of people who are invited to a research study to give their opinions about something

B. the feeling of being involved in an activity or motivated to do it

C. the rate at which employees leave a company

D. the people who participated in a research study

E. a relationship between two things where if one changes, the other one does too

F. the primary or main goal

G. most of the people who responded to a survey

H. the ability of a company to satisfy and keep its employees

Part II Reading Example

Report on Staff Engagement at New Horizon Arts

Introduction

At New Horizon Arts, we are experiencing an annual employee turnover of about 13 percent. Although this might not seem high at first glance, the industry standard is 8 percent. The principal objective of this report is to investigate the causes of employee engagement within the firm and, based on those, offer recommendations to improve the employees' experience of the workplace and increase employee retention.

Research methods

This study was conducted with over 300 employees of New Horizon Arts between July and October 2020, with the aim of understanding their experience and expectations of the workplace. In addition to the 300 questionnaires filled out by employees, 80 also participated in 10 separate focus groups where participants took part in discussions about their levels of engagement in New Horizon Arts and their hopes for the future.

Key research findings

- The top reason for employee disengagement given by 30 percent of those surveyed is the lack of challenging work, followed by having too many working hours (38 percent).
- 42 percent of those surveyed said that the top reason for employees quitting

their jobs was a lack of recognition, while 26 percent stated that it was due to the bad management.
- There was no correlation between salaries and the level of employee engagement.
- 36 percent stated that their levels of engagement would improve if they felt more ownership of their work. 35 percent wanted more flexibility both in terms of working hours and locations. 46 percent were keen to see the company investing more in their career development.
- 63 percent felt that their commitment to the company would improve if they were given training opportunities to improve their business skills. 56 percent rated social and cross-cultural intelligence as the most important skill needed in the workplace.
- 34 percent of respondents felt that there should be increased transparency in company communications, as this would lead to increased trust and more informed decision making.

Recommendations

On the basis of these findings, we recommend that New Horizon Arts adopt a more people-oriented management style. As part of this, we should explore ways of offering more flexible working hours to our employees and consider how we can enable employees to work from their chosen locations. Managers need to consider a variety of ways to challenge our staff and provide more positive reinforcement and recognition of the work they do. Increased investment in professional development, especially in the area of social and intercultural communication, could also contribute to creating a positive environment for employees to produce their best work.

Tips

- Organize your report in sections and give each section a heading.
- State practical details such as where the research was conducted, how many people participated and which methods were used (questionnaires, focus groups, interviews, etc.).
- Use bullet points where appropriate to present points clearly.
- Provide statistics or evidence to back up claims.
- Use an impersonal style of writing in order to sound objective.

Part III Task

Work in groups and write a report on a research study of college students majoring in art in about 300 words. You can choose a research topic based on your own interest.

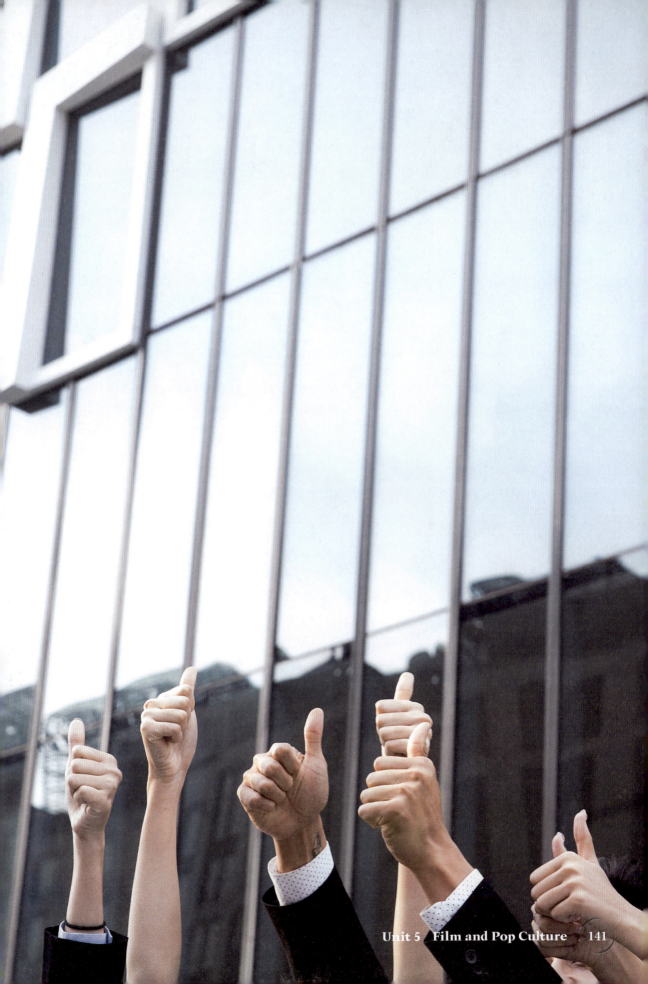

Learning Objectives

Students will be able to:

- understand the vocabulary of the play *Long Day's Journey into Night*;
- describe the plot of the play *Long Day's Journey into Night*;
- understand the vocabulary of Chinese theater art and culture exchange;
- gain an appreciation of the important role of Chinese theater art in international cultural exchange;
- Learn how to write case studies.

Unit 6

Fushion of the Western and Chinese Theater

Lead-In

Task 1 Exploring the Theme

Video 1

Watch a short video clip and then fill in the blanks according to what you have heard.

Segment 1

MARY: Anyway, I don't know what you're 1)_____ to. But I do know you should be the last—right after I returned from the sanatorium, you began to be ill. And the doctor there had warned me I must have 2)_____ at home with nothing to 3)_____ me, and all I've done is to worry about you. But that is no excuse! I'm 4)_____ trying to explain. It's not an excuse! Promise me, dear, you don't believe that I made you an excuse.

Segment 2

MARY: …But how can you understand, when I don't myself. I don't… I don't… I don't understand anything about it, 1)_____ that one day long ago I found that I can no longer call my 2)_____ my own. But I will find it again, dear—some day when you're all well, and I see you healthy and happy and 3)_____, and I don't have to feel guilty any more—some day when the Blessed Virgin gives me 4)_____ the faith that I had my convent days, and I can pray to Her again—when She sees no one else in the world can believe in me even for a moment any longer, then She will believe in me, and with Her help it will be so easy. I will hear myself scream in 5)_____, and at the same time I'll laugh because I'll be so 6)_____ of myself.

Segment 3

MARY: I suppose you'll divide that ten dollars your father 1)_____ you with Jamie. You always divide with each other, like good sports, don't you? Well, I know what he'll do with his 2)_____. He'll get drunk 3)_____ where he can be with the only kind of woman that he likes or understands. Promise me, Edmund, you won't drink! It's so 4)_____. You know Doctor Hardy told you—

EDMUND: I thought he was an old idiot. Anyway, by 5)_____, what will you care?

Video 2
Watch a short video clip and answer the questions.

1) Which school is the most influential style of Dan performance in the history of Peking Opera?

2) What are the characteristics of the performance of "Mei School"?

3) When did Paul Reinsch become a fan of Mei Lanfang?

4) Why did Mei Lanfang become a "voluntary diplomat to the national government"?

5) Why was Mei Lanfang told to postpone his visit to the United States?

6) When did Mei Lanfang set off for the United States?

Unit 6　Fushion of the Western and Chinese Theater

Task 2 Brainstorming

Answer the following questions. Discuss with your classmates and share your answers with the class.

1) What do you think the main themes of Eugene O'Neill's plays are?

2) What is your impression on Mei Lanfang?

Task 3 Building Vocabulary

Talk with your classmates, and try to describe the following words and phrases in English.

the Nobel Prize for Literature	the Pulitzer Prize	ancient Greek tragedy
Mei School	Dan (role type)	

Reading A

O'Neill and His Long Day's Journey into Night

1 Eugene O'Neill (1888—1953) is unquestionably America's greatest playwright, and the only playwright ever to receive the Nobel Prize for Literature[1]. He was the first American playwright to consider drama as serious literature and the first to consistently write tragedies. He saw the theater as a place to present profound ideas. He wanted contemporary American drama to achieve the power of ancient Greek tragedies[2].

2 Before O'Neill's time, Americans saw only imported plays from Europe, such as melodramas, farces, and sentimental comedies[3]. O'Neill wrote 45 plays which were highly experimental

farce *n.* 闹剧；胡闹

1 诺贝尔文学奖。该奖项是根据诺贝尔1895年的遗嘱而设立的五个诺贝尔奖之一，旨在奖励在文学领域创作出具有理想倾向之最佳作品者，诺贝尔文学奖每年评选并颁发一次，由瑞典文学院颁发一枚金牌、一份证书以及一笔奖金。
2 古希腊悲剧。起源于祭祀酒神狄俄尼索斯的庆典活动。戏剧大都取材于神话、英雄传说和史诗，所以体裁通常较严肃。亚里士多德在他的《诗学》中曾专门探讨悲剧的含义。他认为悲剧的目的是要引起观众对剧中人物的怜悯和对变化无常之命运的恐惧，由此使感情得到净化。悲剧中描写的冲突往往是难以调和的，具有宿命论色彩。
3 感伤戏剧。18世纪的一种戏剧体裁，描述中产阶级主角成功克服一系列道德考验。此类种戏剧旨在制造眼泪而不是笑声。

in form and style, combining literary theories of symbolism[1], naturalism[2] and expressionism[3]. He had a great influence on later American playwrights and on playwrights in other countries. After William Shakespeare and Bernard Shaw, O'Neill's plays are translated and produced the most in the world.

3 *Long Day's Journey into Night* was written between 1939 and 1941 but was not produced until three years after O'Neill's death. This long **autobiographical** play describes one day in the life of his own family, his father, his mother, his older brother, and himself. It depicts their **agonized** relationships in a **straightforward** style. Little by little, the play strips away the **pretenses** and defenses of the four characters, revealing the mother to be a defeated drug addict, the father a **frustrated** failure, the older brother a bitter alcoholic, and the youngest son (O'Neill himself as a young man) a **disillusioned** youth with little chance of finding happiness in his life who is also ill.

4 The play has eight scenes. *Long Day's Journey into Night* is

autobiographical *adj.* 自传的；自传体的

agonized *adj.* 感到极度痛苦的；苦闷的

straightforward *adj.* 简单的；坦率的

pretense *n.* 虚假；借口

frustrated *adj.* 不得志的；懊恼的

disillusioned *adj.* 幻想破灭的；不抱幻想的

1 象征主义。西方文学流派之一，19世纪后半叶兴起于法国，影响主要体现在诗歌领域。认为现实世界虚幻而痛苦，要求通过象征、暗示等手段，以恍惚迷离的意向为中介来沟通现实与复杂的内心世界。

2 自然主义。19世纪产生于法国的一种文艺创作手法和流派。主张单纯地描摹自然，记录式地描写现实生活中的表面现象和琐碎细节，因此不能正确地反映社会的本质。以作家左拉（Emile Zola）为代表。

3 表现主义。20世纪初流行于德国、奥地利、法国和北欧的文学艺术流派。表现主义艺术家通过作品着重表现内心的情感，而忽视对描写对象形式的摹写，他们认为主观是唯一真实的，否定现实世界的客观性，反对艺术的目的性。

undoubtedly a tragedy—it leaves the audience with a sense of catharsis, or emotional rebirth as they watch powerful moments, and it depicts the fall of something that was once great. The play focuses on a once-closed family unit that has deteriorated over the years, for many reasons: Mary's drug addiction, Jamie and Edmund's alcoholism, their father's stinginess, the boys' lax attitude toward work and money, and a variety of other factors. When the play is set, the parents are aging, and while they always hoped that their sons would achieve great things, that hope is beginning to be replaced by despair.

5 The play is largely autobiographical; it resembles O'Neill's life in many aspects. O'Neill himself appears in the play as the character Edmund, the younger son who, like O'Neill, suffers from consumption. Indeed, some of the parallels between this play and O'Neill's life are striking. Like James Tyrone, O'Neill's father was an Irish Catholic, an alcoholic, and a Broadway actor. Like Mary, O'Neill's mother was a morphine addict, and she remained so around the time when O'Neill was born. Like Jamie, O'Neill's older brother did not take life seriously, living a reckless life as an actor working at the margins of Broadway, surrounded by prostitutes and alcohol. Finally, O'Neill had an older brother named Edmund who died in infancy; in this play, Edmund has an older brother named Eugene who died in infancy.

6 The play, published posthumously, represents O'Neill's last words to the literary world. It is important to note that his play is not a condemnation; no one character is meant to be viewed as particularly worse than any other. This is one of the play's great strengths; it is fair and unbiased, and it shows that many character flaws can be seen as positives when viewed in a different light. Thus, *Long Day's Journey into Night* invests heavily in the politics of language. It is a world in which there is a large weight

placed on the weakness people see in "stinginess" compared to the virtue of "prudence".

7 The play also creates a world in which communication has broken down. One of the great conflicts in the play is the characters' uncanny inability to communicate despite their constant fighting. For instance, the men often fight amongst themselves over Mary's addiction, but no one is willing to confront her directly. Instead, they allow her to lie to herself about her own addiction and about Edmund's illness. Edmund and Jamie do not communicate well until the last act, when Jamie finally confesses his own jealousy of his brother and his desire to see him fail. James Tyrone, likewise, can only criticize his sons, but his stubborn nature will not allow him to accept criticism. All the characters have bones to pick, but they have trouble doing so in a constructive fashion.

8 Most of these grudges stem from the past, which is remarkably alive for the Tyrones. Mary in particular cannot forget the past and the dreams she once had of being a nun or a pianist. Tyrone too has always had high hopes for Jamie, who has been a continual disappointment. Past problems and conflicts cannot be forgotten, and in fact, they seem doomed to be relived day after day. It is important to note that *Long Day's Journey into Night* is not only a journey forward in time, but also a journey back into the past lives of all the characters, who continually fall back into their old lifestyles. We are left as an audience realizing that the family is not making progress towards betterment, but rather continually sliding into despair, bound to a past that they can neither forget nor forgive.

9 The play is all the more tragic because it leaves little hope for the future; indeed, the future for the Tyrones can only be seen as one long cycle of a repeated past constrained by alcohol and morphine. This play was awarded the Pulitzer Prize[1] when

1 普利策奖。根据美国报业巨头约瑟夫·普利策的遗愿于1917年设立的奖项，每年评选一次，普利策奖包括14项新闻类奖项和7项创造类奖项，普利策戏剧奖是其中之一。

it was first published, and it has remained one of the most admired plays of the 20th century. Perhaps most importantly, it has achieved commercial success because nearly every family can see itself reflected in at least some parts of the play. The Tyrone family is not a unique family, and it is easy to identify with many of the conflicts and characters. The play has a unique **appeal** to both the individual audience members and scholars of American drama, which explains its popularity and **enduring** acclaim.

appeal *n.* 启发；感染力；恳求

enduring *adj.* 持久的；能忍受的

10 O'Neill's great purpose was to try and discover the root of human desires and frustrations. Most of the characters in his plays are portrayed as seeking meaning and purpose in their lives, some through love, some through religion, others through **revenge**, but all meet disappointment. O'Neill and his characters find human nature perplexing, and frequently comment upon it. Most of his plays are **pessimistic**, leaving the characters disillusioned or without hope.

revenge *n.* 报复；复仇

pessimistic *adj.* 悲观的；悲观主义的

(1075 words)

(From wikipedia website.)

Part I Understanding the Text

Task 1 Global Understanding

1. Read the text, and identify the main idea.

1) According to the text, what is *Long Day's Journey into Night* mainly about?

2) Can you write down the name of each character and how the role is introduced?

 Character 1: _____

 Character 2: _____

 Character 3: _____

 Character 4: _____

2. Read the text and decide whether the following sentences are true (T) or false (F).

(　　) 1) Eugene O'Neill was one of the greatest American playwrights, and he won the Nobel Prize for Literature.

(　　) 2) Eugene O'Neill only influenced later American dramatists.

(　　) 3) Eugene O'Neill regarded theater as a place to show tragic thought.

(　　) 4) The play *Long Day's Journey into Night* was critically lauded and it resulted in a commercial hit.

(　　) 5) Most of O'Neill's plays are tragicomic, in which the characters are disappointed and hopeful.

Task 2 Detailed Understanding

1. Read the text again and choose the best answer to each question below.

1) Which of the following characters lived an irresponsible life as an actor working at the margins of Broadway in the play?

 A. Mary.　　　　B. Jamie.　　　　C. James.　　　　D. Edmund.

2) What does "sentimental comedies" in Paragraph 2 mean?

 A. A drama of light and amusing character and typically with a happy ending.

 B. A dramatic genre of 18th century, denoting plays in which middle-class protagonists triumphantly overcome a series of moral trials. These are comedies aimed at producing tears rather than laughter.

 C. A light dramatic play marked by broadly satirical comedy and an improbable plot.

 D. A drama in which many exciting events happen, and characters have very strong or exaggerated emotions.

3) Why does the author say "The play has a unique appeal to both the individual audience members and scholars of American dramas, which explains its popularity and enduring acclaim."?

 A. Because the play is very tragic.

 B. Because only scholars of American dramas laud the play.

 C. Because nearly every family can see itself reflected in at least some parts of the play.

 D. Because at that time American people could only watch O'Neill's plays.

2. Answer the following questions according to the text.

1) What is the meaning of "autobiographical play" in Paragraph 3?

2) According to the text, why has Eugene O'Neill's play *Long Day's Journey into Night* remained one of the most admired plays of the 20th century?

3) What is the meaning of the sentence "He wanted contemporary American drama to achieve the power of ancient Greek tragedies." in Paragraph 1?

Part II Building Language

Task 1 Key Terms

The words or phrases below are related to theater. Discuss with your classmates and provide your understanding about each term in English.

1) tragedy: _____

2) autobiographical play: _____

3) pessimistic: _____

4) Broadway: _____

5) popularity: _____

6) contemporary: _____

7) farce: _____

8) conflict: _____

9) sentimental comedy: _____

10) scene: _____

11) act: _____

12) pretense: _____

Task 2 Vocabulary

Choose the correct word or phrase from the box below to complete each of the following sentences. Change the form where necessary.

appeal	profound	pretense	grudge	suffer from
constantly	stem from	strip away	condemnation	unbiased
prudence	uncanny	straightforward	be doomed to	posthumously

1) Your enjoyment of a melodrama can _____ too much analysis and dissection.

2) I once thought that I would like to be a movie star, but my rejected audition led to a(n) _____.

3) The act itself is quite simple, you _____ the outer layer, and reveal what's underneath.

4) Everyone's life journey will _____ pass through a period of "crazy" days, but we must wait until after old age to realize how ridiculous it is.

5) In the absurd comedy his character was a(n) _____ man who simply repeated everything he had seen.

6) People expressed their firm opposition and strong _____ of the actors who evaded paying taxes.

7) This low comedy made the audience question their morals and offered a(n) _____ to emotion instead of logic.

8) There was never any _____, even after she became famous.

9) This is a script full of _____, original, and complex insights.

10) The playwright is your brother, but can you give a(n) _____ opinion about the play?

11) Gossip and speculation about upcoming productions are _____ fed to fans by the media.

12) He was _____ awarded a Lifetime Achievement award from the Performing Arts Association in 2021.

13) The huge success of the experiment play _____ its spirit of innovation and inventiveness.

14) These businessmen are showing remarkable _____ in investing in neorealist theater.

15) It gives his suspense play a(n)_____ features: the familiar became unfamiliar, and the normal became suspicious.

Part III Translation

1. Translate the following sentences into Chinese.

1) He was the first American playwright to consider drama as serious literature and the first to consistently write tragedies. He saw the theater as a place to present profound ideas.

2) O'Neill wrote 45 plays which were highly experimental in form and style, combining literary theories of symbolism, naturalism and expressionism.

3) *Long Day's Journey into Night* is undoubtedly a tragedy—it leaves the audience with a sense of catharsis, or emotional rebirth as they watch powerful moments, and it depicts the fall of something that was once great.

4) When the play is set, the parents are aging, and while they always hoped that their sons would achieve great things, that hope is beginning to be replaced by despair.

5) O'Neill and his characters find human nature perplexing, and frequently comment upon it. Most of his plays are pessimistic, leaving the characters disillusioned or without hope.

2. Translate the following sentences into English.

1) 自传体戏剧《长夜漫漫路迢迢》毫无疑问标志着奥尼尔文学创造的巅峰。这部剧今天依然广受欢迎、享有盛誉。

2) 作为一位严肃剧作家，奥尼尔笔耕不辍，创造了 45 部剧作，其中许多作品刻画了幻想破灭的主人公，探讨了人类欲望和挫败的根源。

3) 奥尼尔不断尝试新的体裁和形式，将欧洲戏剧最好的传统——无论是表现主义、自然主义，还是象征主义——融合在一起，表达出他对生活以及人性的广泛兴趣。

4) 奥尼尔经常在他的作品中表现东方思想，尤其是道教思想。这不仅是为了艺术效果的呈现，也是为了尝试发现解决西方社会问题的良方。

5) 北京人民艺术剧院正在上演新编的曹禺三部经典剧作：《日出》《雷雨》和《原野》，以致敬像曹禺一样的中国先驱剧作家。曹禺深受奥尼尔作品的影响。

Reading B

Western Flavors in Chinese Theater Art

A blend of Eastern and Western cultures in Chinese theater art is the trend.

1 In 1930, famous Chinese Peking Opera artist Mei Lanfang landed in the United States to give a performance. People from theater and film circles together with other interested **spectators embraced** this rare chance to taste Chinese theater art. A wide variety of American spectators, including British-born film star Charlie Chaplin, were amazed by the Eastern art.

2 In 1935, Mei Lanfang and his team visited the Soviet Union for a performance tour, stirring up a wave of **adoring** and studying Chinese theater art in Moscow and other cities. Celebrities from across the country gathered to watch Peking Opera. Mei Lanfang **wowed** audiences with minimal costume and set, which surprised many famous Soviet theater legends. Famous artists from the Soviet such as Konstantin Stanislavski[1],

spectator *n.* 观众
embrace *v.* 欣然接受；乐意采纳

adore *v.* 崇拜；热爱

wow *v.* 使印象深刻；使叫绝

1 康斯坦丁·斯坦尼斯拉夫斯基，俄国演员、导演，戏剧教育家、理论家。著有《演员的自我修养》等。斯坦尼斯拉夫斯基体系在中国博得梅兰芳等戏剧家的高度评价，并对中国戏剧产生了深远的影响。

Vsevolod Meyerhold[1], and Sergei Eisenstein[2] expressed deep admiration for the profound Chinese theater art presented by Mei Lanfang. German theater director Bertolt Brecht[3] credited inspiration from Mei Lanfang's performance for his "distancing effect"[4] theory.

3 Mei Lanfang's overseas tours not only showed the world the charm of Chinese theater art, but also offered a window for many to better understand China and traditional Chinese culture. As a master of Peking Opera, Mei was a great patriot devoted to developing China's cultural and art **undertakings**. During his stage practice, which lasted more than 50 years, Mei respected traditions while also bravely taking an **innovative** approach that constantly enriched and transformed his own performing art.

undertaking *n.* 工作；任务；事业

innovative *adj.* 创新的；新颖的

4 Mei Lanfang was a perfectionist who went on to learn all the facets of his motherland's opera art, raising its level to the peak of Peking Opera performance, creating many beautiful and memorable artistic moments along the way. He was a diligent and **studious** actor, applying his mind to Chinese classical literature, painting, music, dance, folklore, **phonology** and costume studies. He **incorporated** this knowledge into his own art, creating many excellent dramas and developing the Mei School, an artistic institution with a unique style. Mei Lanfang

studious *adj.* 好学的

phonology *n.* 音系学；音韵学；语音体系

incorporate *v.* 合并；包含；融合

1 弗谢沃洛德·梅耶荷德，导演、演员、戏剧理论家，与斯坦尼斯拉夫斯基并列为 20 世纪最重要的戏剧大师。他热情赞美东方戏剧并从中汲取营养，他认为中国的戏剧艺术是赋予动作以巨大意义的戏剧艺术之一。

2 谢尔盖·爱森斯坦，导演、电影理论家、俄罗斯电影之父。他是电影学中蒙太奇理论奠基人之一。

3 贝托尔特·布莱希特，现代戏剧史上极具影响力的剧场改革者、剧作家及导演，被视为当代"教育剧场"的启蒙人物。布氏剧作及戏剧理论对当代戏剧界产生过巨大的影响，并由此成为各国戏剧家的主要研究对象。

4 间离效果，又称"陌生化效果"，指让观众看戏，但并不融入剧情。间离效果是叙述体戏剧运用的一种舞台艺术表现方法，是布莱希特从中世纪民间戏剧和梅兰芳的表演中发现并加以发展而来的。

played a major role in carrying forward the past and **ushering** in the future development of modern Chinese drama, and he is acknowledged both in China and internationally as a supreme performer and the **embodiment** of beauty.

5 After the founding of the People's Republic of China in 1949, Chinese theater art became an important **conduit** for cultural exchange between China and other countries. Famous **troupes** and artists practicing various major types of Chinese theater art went abroad to perform representative plays and build bridges for friendship between China and foreign countries.

6 Chinese opera troupes visiting foreign countries primarily sought cultural exchange, so the plays they performed were mainly classical Chinese theater art. They conveyed historical stories, humanistic spirit, and moral values of China. Alongside local officials and cultural consumers, overseas Chinese people accounted for the majority of the audience. Watching operas brought from the motherland helped ease their homesickness.

7 Since the beginning of China's reform and opening up in the late 1970s, overseas performances of Chinese theater art started embracing business opportunities in addition to **fostering** cultural exchange. Performances were no longer confined to traditional Chinese theater art. Interpretation of Western classics through Chinese theater art forms also emerged.

8 During this period, many operas with both Chinese and Western elements were staged. The Peking Opera version of *Othello*[1] created and performed by the Jingju Theater Company of Beijing in the late 1970s was a highly successful Shakespearean **adaptation**. *The Crimson Palm*, performed by the Shanghai Kunqu Opera Troupe, was adapted from *Macbeth*[2].

1 《奥赛罗》，莎士比亚四大悲剧之一，创作于 1603 年。作品讲述威尼斯公国勇将奥赛罗与元老的女儿苔丝狄蒙娜相爱并成婚，却受到手下旗官伊阿古挑拨，在愤怒中掐死了自己的妻子，后得知真相，悔恨之余拔剑自刎。

2 《麦克白》，莎士比亚四大悲剧之一，创作于 1606 年。《麦克白》的故事大体上是根据古英格兰史学家拉斐尔·霍林献特的《苏格兰编年史》中的古老故事改编而成，讲述了利欲熏心的国王和王后由于对权力的贪婪及其行为，最后被推翻的过程。

Peking Opera shows *Dragon King*[1] and *Sakamoto Ryoma*[2] were jointly developed by China and Japan in the 1980s. The Kunqu Opera play *Twilight Crane*[3] is based on a Japanese story. These works either used Chinese theater art forms to perform foreign masterpieces or injected Chinese theater art with elements of Western art. They all combined Eastern and Western cultures and arts.

A still from the Peking Opera play *Othello* presented by the Jingju Theater Company of Beijing

1 《龙王》，由单独的京剧部分、单独的歌舞伎部分及京剧和歌舞伎共演部分，共3幕14场次所组成。故事讲述了一个凶残的龙王诱拐了中日混血儿海彦的日本妻子天道。海彦在中国少年哪吒的帮助下，救出了天道，打败了龙王。《龙王》一剧自1986年10月开始构想，经过中日两国艺术家的密切合作，于1988年2月完成。

2 《坂本龙马》，是已故日本著名剧作家真山青果先生的杰作之一。我国剧作家吕瑞明将其改编成京剧，并于1992年中日邦交正常化20周年之际在京公演。《坂本龙马》讲述了日本江户时代末期志士坂本龙马参与倒幕维新运动中发生的一系列故事。

3 《夕鹤》，由北方昆曲剧院根据日本同名话剧改编的昆曲剧目。1994年首演于北京。剧情讲述了在仙鹤南迁中，青年农民与平救下一只伤鹤。鹤为报恩化为姑娘阿慈嫁给与平，并拔下自己的羽毛为与平织作锦衣。后来与平受人教唆逼迫阿慈织更多的锦衣，并且违反约定，偷看阿慈纺织，阿慈只得又变为仙鹤离开了与平。

Unit 6 Fushion of the Western and Chinese Theater

9 Two major styles are used to adapt Western operas to Chinese theater style. One is to costume characters in Western-style clothing and hair while singing in Peking Opera rhyme. During the performance, performers play the roles of a Western opera with only a subtle Chinese theater style. Because of **incompatible** elements of Chinese theater art and Western operas such as names, certain behavior, and story structure, performances can be strange.

incompatible *adj.* 不相容的；不兼容的；不能和谐相处的

10 The other method is to adapt Western operas to **comparable** Chinese stories and characters while saving the story structure of the original work, so actors can play Chinese roles with natural dialogue and action against a Chinese cultural backdrop. This method avoids conflict **in terms of** cultural background, language, action, and style, and makes the production more natural. Many consider this style of opera a purer form of art because it provides reasonable space for the unique characteristics of Chinese theater art. Western audiences have also been amazed and attracted by the emotions expressed by this unique Eastern style and often left with an even stronger impression than Western plays.

comparable *adj.* 类似的；相当的；可比的

in terms of 在……方面；从……方面来说；根据……来看

11 For example, a Henan Opera adaptation of Strindberg's *Miss Julie*[1] was produced by the acting department of the National Academy of Chinese Theater Arts. A Henan Opera troupe presented an adapted version of *Much Ado About Nothing*. The original work was adapted into a Chinese story, and Chinese characters were used. The opera's singing and dancing was still on full display, creating space for reasonable exploration of singing and dancing. Finding works more easily adapted to a traditional Chinese theater art structure has produced stronger results.

1 《朱莉小姐》，根据瑞典剧作家斯特林堡的代表作 *Miss Julie* 改编，是中国戏曲学院创作的豫剧多幕剧。2017 年 11 月，荣获第六届北京大学生戏剧节多幕剧（专业组）金奖。主要讲述身在豪门的朱莉终日苦闷，某个元宵节晚上，寂寞难耐的朱莉欲与仆人项强私奔，但后来项强的自私、恶毒让她失去了对生活的希望。

A still from the Henan Opera play *Much Ado About Nothing* adapted from Shakespeare's play of the same name by the National Academy of Chinese Theater Arts

12 By utilizing plot lines of plays familiar to Western people, foreign spectators can understand productions more easily without subtitles and better focus on appreciation of the dramatic art of Eastern culture presented by Chinese artists. When audiences are already familiar with the content of the play, they are more able to understand the Chinese culture fueling the production. In the internet era, Chinese theater art is playing an even more active role in international cultural exchange. Blending cultures in Chinese theater art is the modern trend.

fuel *v.* 增加；加强

(999 words)

(From: *China Pictorial*, 2021(2).)

Part I Understanding the Text

Task 1 Global Understanding

1. Read the text and answer the following questions.

1) Talk with your classmates and discuss about Mei Lanfang's important role in the development of Chinese theater art.

2) After the reform and opening up, what are the changes of Chinese theater art in cultural exchanges between China and foreign countries?

2. Write down the key idea of each paragraph below.

1) Paragraph 4: _____

2) Paragraph 8: _____

3) Paragraph 12: _____

Task 2 Detailed Understanding

1. Read the text again and answer the following questions according to the text.

1) What kinds of plays did Chinese opera troupes mainly perform when visiting foreign countries? Can you give reasons why they made such choices?

2) Two major styles are used to adapt Western operas to Chinese theater style. What are they?

2. Discuss with your classmates, write the main ideas of the following plays. Search the Internet for information when necessary.

Plays	Main Ideas
The Crimson Palm	
Dragon King	
Twilight Crane	
Miss Julie	

Part II Building Language

Task 1 Key Terms

The words or phrases below are related to theater. Discuss with your classmates and provide your understanding about each term in English.

1) spectator: _____

2) profound: _____

3) phonology: _____

4) usher: _____

5) embodiment: _____

6) foster: _____

7) adaptation: _____

8) incompatible: _____

9) comparable: _____

10) in terms of: _____

Task 2 **Vocabulary**

Replace the underlined parts in the following sentences with the expressions below that best keep the original meaning.

> confined conduit facet conveyed undertaking
> embraced innovative adored studious fueled

1) The new rules have been <u>supported</u> by government organizations.

2) She <u>loved</u> her parents and would do anything to please them.

3) It was a huge <u>difficult task</u> but they were very determined.

4) Your <u>original</u> ideas spark exciting changes at work and home.

5) He has travelled extensively in China, recording every <u>side</u> of life.

6) Andy's round glasses made him look <u>hardworking with his books</u>.

7) It could provide a <u>channel</u> for increased aid to the poor.

8) All this information can be <u>communicated</u> in a simple diagram.

9) Health officials have successfully <u>restricted</u> the epidemic to this area.

10) His words <u>inflamed</u> her anger still more.

Part III Translation

1. Translate the following sentences into Chinese.

1) During his stage practice, which lasted more than 50 years, Mei respected traditions while also bravely taking an innovative approach that constantly enriched and transformed his own performing art.

2) Mei Lanfang played a major role in carrying forward the past and ushering in the future development of modern Chinese drama, and he is acknowledged both in China and internationally as a supreme performer and the embodiment of beauty.

3) Chinese opera troupes visiting foreign countries primarily sought cultural exchange, so the plays they performed were mainly classical Chinese theater art. They conveyed historical stories, humanistic spirit, and moral values of China.

4) The other method is to adapt Western operas to comparable Chinese stories and characters while saving the story structure of the original work, so actors can play Chinese roles with natural dialogue and action against a Chinese cultural backdrop.

5) By utilizing plot lines of plays familiar to Western people, foreign spectators can understand productions more easily without subtitles and better focus on appreciation of the dramatic art of Eastern culture presented by Chinese artists.

2. Translate the following sentences into English.

1) 为外国观众表演京剧时，不要低估西方人对京剧的理解能力。通过准备像样的英文节目单和字幕可以帮助西方观众逐步建立起欣赏京剧的正确模式。

2) 梅兰芳曾说："我是个笨拙的学艺者，没有充分的天才，全凭苦学。我到今天还是一个努力的小学生。"

3) 许多现代中国人不喜欢京剧，它似乎既是一种后天养成的品位，也是一种广受老年人喜爱的艺术形式。对京剧的品位往往是在几十年中慢慢培养起来的，西方歌剧也是如此。

4) 尽管西方歌剧和京剧代表不同的文化，但它们有很多相似之处。例如，为了发展和成长，两者都从对方那里借鉴了一些元素。

5) "传统戏曲只有与时俱进才能生存，"一位著名京剧演员说，"我希望京剧能够在世界上产生更大的影响，它的理论在全球范围内被广泛地学习与讨论，就像我们对待著名戏剧理论家贝托尔特·布莱希特和康斯坦丁·斯坦尼斯拉夫斯基的理论那样。"

Writing Skills

Writing Case Studies

Part I Preparation

Task 1 Introduction

The study of a person, a small group, a single situation, or a specific "case", is called a case study. A successful case study analyzes a real-life situation where existing problems need to be solved. The purpose of a case study is to develop and demonstrate an understanding of a real-life case, and make a decision about it.

Task 2 Preparation Task

Match the words on the left with the definitions on the right.

1)	synopsis	A	a word, phrase, or idea which comes from sth. such as a book, poem, or play and which you use when making a point about sth.
2)	outline	B	to make sth. that has been officially decided start to happen or be used
3)	identify	C	a way of dealing with sb./sth.; a way of doing or thinking about sth. such as a problem or a task
4)	analyze	D	a summary of a piece of writing, a play, etc.
5)	approach	E	a way of solving a problem or dealing with a difficult situation

6) reference **F** to find or discover sb./sth.

7) solution **G** to give a description of the main facts or points involved in sth.

8) implement **H** to examine the nature or structure of sth., especially by separating it into its parts, in order to understand or explain it

Part II Reading Example

Launching an Expanded and Renovated Art Museum

National and international media relations campaign to launch the Harvard Art Museums' renovated and expanded home and inaugural exhibitions.

Approach

In March 2012, Resnicow and Associates (R+A) began working with the Harvard Art Museums on an institutional communications and media relations campaign for the Museums' expanded and updated facility designed by Renzo Piano. The campaign began with a comprehensive assessment and planning process, including working with the museums' team to develop core institutional messages, identify and prioritize key constituencies, and develop strategies to engage with these audiences across multiple platforms.

The campaign was designed to achieve the following goals:

- raise the profile of the Harvard Art Museums as an international leader in the fields of scholarship, professional training, and conservation;
- increase awareness of the breadth and depth of the Harvard Art Museums' collections;
- underscore the quality and continuing growth of the Harvard Art Museums' contemporary art collection and initiatives.

Our campaign focused on the Museums' role as a catalyst in new areas of conservation, scholarship, and exhibition. R+A organized tours of the site throughout

the construction process for opinion-leading national and international journalists, as well as behind-the-scenes access to the work of project leadership in support of stories in art trade, travel, design, and leading national and international news outlets.

Results

The campaign generated press coverage of the Harvard Art Museums across local, national, and international online, print, and broadcast outlets. Coverage in travel and lifestyle media outlets highlighted the Museums as a destination for the public as well as the University and scholarly community, while major reviews in architectural outlets explored how the new design fosters the Museums' mission. Reviews and features in the art press highlighted the integration of the collection, the contemporary art installations, and explored how the Museums are advancing curatorial practice.

Tips

- Write an executive summary at the beginning to outline the purpose of the case study.
- Identify the problems, recommend the solutions and detail how these solutions should be implemented.
- Attach any original data that related to the study in the appendices (if any).

Part III Task

Suppose you are working for an entertainment company and are going to introduce Chinese art to overseas audience. Write a case study on a Chinese play, movie, actor, etc. to decide whether the piece of work or the person is appropriate to be introduced. You should write in at least 200 words but no more than 300 words.

Learning Objectives

Students will be able to:

- understand the vocabulary of T-shirts;
- describe the social influence of fashion;
- understand the vocabulary of fashion dissemination;
- gain an appreciation of Chinese fashion style;
- write an essay.

Unit **7**

The Influence of Fashion on Society

Lead-In

Task 1 Exploring the Theme

Listen to a passage and fill in the blanks.

1) The nature of fashion is often _____ because it is viewed as an art which requires so much creativity to start, while it is run as a business that needs more technology and management to realize.

2) All these contradictory elements, _____, individuality and popularity, worked together to keep the fashion dynamic and ever changing.

3) It is fashion _____ that bridges the gap between the intangibilities of fashion and the concrete realities of business.

4) One way is to release the fashion trends and demonstrate how these might be applied in daily life through _____.

5) No matter which way it is, dissemination provides a contemporary _____ to fashion, setting up desirable images and establishing the relationship between fashion and their everyday life.

Task 2 Brainstorming

Answer the following questions. Discuss with your classmates and share your answers with the class.

1) What kind of social influences can T-shirts have?

2) What are the characteristics of Chinese fashion style?

Task 3 Building Vocabulary

Talk with your classmates, and try to describe the following words and phrases in English.

walking billboard	political poster	fashion dissemination
Chinese fashion style	Wuyong	

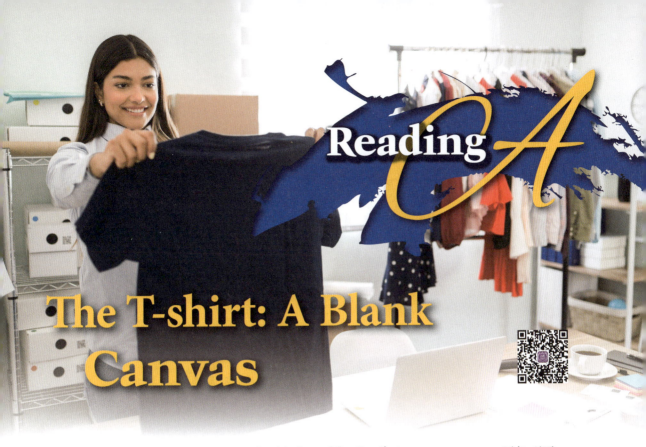

Reading A

The T-shirt: A Blank Canvas

1 From humble beginnings, the T-shirt, like Levi's jeans, transformed itself from a basic working-class, **utilitarian** garment into a postmodernist signpost that advertised and expressed personal interests and individual beliefs. Constructing identity through lifestyle is determined by the type of popular cultural products we consume and the creative uses into which we put these products or commodities. The T-shirt, just like the **beanbag**, spoke to one's emotional and sensual, rather than functional needs. The quest to define "self" among postmodernist youth culture was paralleled by the popularity and the rise of the T-shirt. The new consumerist-led society relied on diversity and changeability, which was precisely what the inexpensive T-shirt offered.

2 Like blue jeans, T-shirts have become cultural icons, and are usually discussed within a **paradigm** of sociability and leisure lifestyles. The visual **pluralism** that they offer includes expressions of social or political beliefs or **affiliations**, and likes or interests, and they easily become an advertisement for commercial products or a medium for self-expression. They replace postcards or photographs, depicting the places that one has visited, as well as acting as a **souvenir** of one's travels. The

canvas *n.* 画布；油画
utilitarian *adj.* 功利（主义）的；实用（主义）的

beanbag *n.* 沙包；豆袋坐垫

paradigm *n.* 范例；示例
pluralism *n.* 多元性；多元化
affiliation *n.* 隶属（关系）；从属关系；联系
souvenir *n.* 纪念品；纪念物

"I ♥ NY" (Illustration 1) slogan by Milton Glasier[1] has been copied by cities around the world, but originated in New York—the home of the quick message. Madison Avenue[2], famous for its "ad men", used T-shirts in the 1940s to gain support for the presidential elections. Long before anyone else, they comprehended the potential of clothing as a new form of visual dialogue.

Illustration 1

tattoo *n.* 纹身
mandatory *adj.* 强制的；必须履行的；法定的
sartorial *adj.* 裁缝的；缝纫的

genocide *n.* 大屠杀；种族灭绝

3　The T-shirt has been described as a form of "political poster", and as a **tattoo** that "acts as a second skin". As a graphic tool, it has become a **mandatory** means of **sartorial** protest for the young. Protest campaigns about Civil Rights[3] and the Vietnam War[4] were referenced in the visual arts. Graphic designers such as R&K Brown in their appropriated Iwo Jima[5] photograph, and George Maciunas's[6] American Flag poster protested about the **genocide** committed by American troops in conflicts over the century. In 1968, Japanese artist Hirokatsu[7], as a reminder of the Second World War, created a poster entitled

1　梅顿·戈拉瑟（1929—2020），美国著名平面设计师，1977年设计了"I ♥ NY"这个图标，用于纽约市的旅游宣传。
2　麦迪逊大道，位于纽约市上东区，是北美最大的豪华高端购物区。
3　美国黑人民权运动，又称"非裔美国人民权运动"，是美国民权运动的一部分，于1950年兴起，1970年结束。这是一场经由非暴力的抗议行动争取非裔美国人民权的群众斗争。
4　越南战争。指在第二次世界大战后的1955年11月，东南亚爆发的一场大规模局部战争，对亚洲国际政治产生了深远的影响。
5　硫磺岛。日本在太平洋上的一个小岛，"二战"中美军经历一番苦战才拿下该岛。在美国华盛顿特区有一座以美军陆战队胜利登岛后升美国国旗为主题的雕塑。
6　乔治·麦素纳斯，美国激浪派艺术的开创者。
7　土方弘克（1941—　），日本艺术家、平面设计师。

"*No More Hiroshimas*". Ron Borowski created a **sardonic** photograph of an African American, with an American flag **superimposed** over his face, reading: "I **pledge allegiance** to the flag of the U.S. …where all men are created equal." T-shirts were worn to street marches as a sign of peaceful protest, with their verbal and visual references acting as effective communication tools, bridging language and cultural barriers. Both the **hippies** of the 1960s and the **punks** of the 1970s used the T-shirt as a means of protest and **propaganda**, with perhaps one of the most controversial things being produced by fashion designer Vivienne Westwood[1] in 1977. A T-shirt with the image of Queen Elizabeth with a safety pin through her nose was a bold political statement that enraged the British, and was seen as an unforgivable act of rebellion.

sardonic *adj.* 讥讽的；冷嘲的；轻蔑的

superimpose *v.* 使（尤指图片、文字等）叠加；将……放在他物之上

pledge *v.* 发誓；保证

allegiance *n.* （对统治者、国家、群体或信仰的）忠诚；拥护

hippie *n.* 嬉皮士

punk *n.* 朋克摇滚乐；朋克摇滚乐迷

propaganda *n.* 宣传；鼓吹

4 With the invention of **plastisol** in 1959, a plastic printing ink that couldn't be washed out of fabric, plastic transfers and spray paint, the mass production of T-shirts gathered speed in the 1960s. By 1965, marketing professionals had begun to recognize the T-shirt as a medium for exploiting product branding internationally. As a walking billboard, they provided unpaid advertising for companies such as Budweiser, Coca Cola, Disneyland and later, sporting companies such as Nike and Slazenger[2]. The use of constant repetition as a tool, adopted by commercial television advertisements to **hypnotize** viewers, inspired Andy Warhol's[3] **silkscreen** multiple prints of Campbell's soup tins.

plastisol *n.* 塑料溶胶

hypnotize *v.* 着迷于；沉醉于

silkscreen *n.* 丝网印刷术

5 In the same way, Warhol's images were seen as a blast comment on consumerism and the **manipulation** of the public by advertising agencies and media corporations. The T-shirt serves as the similar purpose. They use both irony and satire

manipulation *n.* 操纵（出于个人利益操纵某人或某事，常指使用不公平或不诚信的方式）

1 维维安·韦斯特伍德（1941— ），英国时装设计师，被誉为时装界的"朋克之母"。
2 史莱辛格，英国邓禄普（DUNLOP）公司旗下的运动品牌，也是英国的皇室贵族品牌。
3 安迪·沃霍尔（1928—1987），20世纪美国最重要的艺术家之一，波普艺术的倡导者和领袖，也是对波普艺术影响最大的艺术家。

to critique the **superficialities** of society. Most effectively, they are used as a means of expressing **cynicism** about the dominant culture. They can make **provocative** statements about racism, gender **discrimination**, violence and **obscenity**. Postmodernist artists use humor extensively to point out the contradictions and complexities of modern life. As a form of self-expression or self-branding, the T-shirt conveys messages to others indicating one's preference for a particular style of music or band, and acts as a conversational **catalyst** for like-minded people. Musicians and rock groups use T-shirts as "**memorabilia** retailing" for their tours, seen as an important part of the promotional **fanfare**. Slogans such as "I'm High on Life" "The Anti-Everything T-Shirt" and "Born Free" were popular in the 1960s and 1970s.

6 Fashion historian Leslie Watson explains how the 1980s ushered in political correctness and social awareness in London. She notes that designer Katherine Hamnett[1] launched a T-shirt collection called "Choose Life" (Illustration 2) — clothes with a social message, including "Stop Acid Rain" "Preserve the Rainforests" and "58% Don't Want Pershing[2]". The last-mentioned shirt (a protest against the deployment of American nuclear weapons in Britain) was worn by the designer herself when she met Prime Minister Margaret Thatcher at Downing Street in 1984 (Illustration 3). Ecological T-shirts were made of cotton that had been grown without the use of **pesticides** or from recycled materials. It seems that the greater the commitment to a cause is, the more **blatant** the message becomes.

Illustration 2 Illustration 3

1 凯瑟琳·哈玛尼特，英国当代时装设计师。
2 潘兴导弹，美国部署在欧洲和英国的核导弹。

7 Clothing speaks to both strangers and observers. In art, like fashion, the T-shirt has been used to reflect the culture of the street and the everyday, and has turned T-shirts with slogans into art objects. Artist Jenny Holzer[1] produced an "Abuse of Power Comes as No Surprise" T-shirt, while **graffiti** artist Keith Haring[2] used T-shirts to bridge the gap between the street (the subway, actually) and the museum. These T-shirts—also Hamnett's[3] protest shirts—were exhibited at the Documenta VII exhibition, held at the Fashion Moda Gallery[4] in East Village New York in 1982. A critic in an article entitled "**Rapture**: Art's Seduction by Fashion" remarks that: "For a while, both art and fashion were unified in making the billboard for the body."

graffiti *n.* 涂鸦；涂画

rapture *n.* 狂喜；欢天喜地；兴高采烈

(989 words)

(Adapted from: English, B. *A Cultural History of Fashion in the 20th and 21st Centuries: From Catwalk to Sidewalk*. London: Bloomsbury, 2018.)

1 珍妮·霍尔泽，美国人，当代国际上少数几位以观念性著称的女性艺术家。
2 凯斯·哈林（1958—1990），20 世纪 80 年代美国街头绘画艺术家和社会运动者。
3 英国时尚品牌，创始人为时装设计师凯瑟琳·哈姆尼特。
4 莫达时尚展览馆。

Part I Understanding the Text

Task 1 Global Understanding

1. Read the text and decide whether the following sentences are true (T) or false (F).

() 1) The quest to define "who I am" among postmodernist youth culture was paralleled by the popularity and the rise of the T-shirt.

() 2) The hippies of the 1960s used the T-shirt as a means of protest and propaganda while the punks of the 1970s didn't according to the text.

() 3) Political correctness and social awareness were ushered in London in the 1970s.

() 4) T-shirts have been used as irony and satire to critique the superficialities of society.

() 5) Cotton T-shirts are said to be ecological if pesticides are not used in the cotton field.

2. Match the main ideas to the paragraphs below.

Paragraph 1	A. T-shirts have become cultural icons and can be used to express social or political beliefs or affiliations, and likes or interests.
Paragraph 2	B. T-shirts with slogans has been turned into art objects.
Paragraph 3	C. The T-shirt has transformed itself from a basic working-class garment into a postmodernist signpost that advertised and expressed personal interests and individual beliefs.
Paragraph 7	D. The T-shirt has been described as a form of "political poster", and as a tattoo that "acts as a second skin".

Task 2 Detailed Understanding

1. Answer the following questions according to the text.

1) What is the meaning of "ad men" in Paragraph 2?

2) What helped the mass production of T-shirts gather speed in the 1960s according to the text?

3) In what sense T-shirt, as a graphic tool, has become a mandatory means of sartorial protest for the young?

2. Discuss the following questions with your partner.

1) What is the influence of fashion on society according to the text?

2) In what sense can T-shirt be described as a form of "political poster"?

3) How do you understand the sentence "For a while, both art and fashion were unified in making the billboard for the body" in Paragraph 7?

Part II Building Language

Task 1 Key Terms

The words or phrases below are related to fashion's influence on society. Discuss with your classmates and provide your understanding about each term in English.

1) recycled material: _____

2) cultural icon: _____

3) walking billboard: _____

4) silkscreen: _____

5) utilitarian: _____

6) consumerism: _____

7) T-shirt collection: _____

8) graffiti: _____

9) postmodernist: _____

10) pluralism: _____

Task 2 Vocabulary

Read the text carefully and complete the sentences with the words below. Change the form where necessary.

recycle	affiliation	silkscreen	rapture	discrimination
paradigm	canvas	pluralism	pledge	provocative
graffiti	like-minded	catalyst	hypnotize	superimpose

1) We were completely _____ by her performance of the Mozart.

2) The overall social and political project is the creation of a harmonious, democratic cultural _____, a healthy cultural diversity.

3) He decorated the office with paintings and _____.

4) He listened to the wind in the trees, his eyes closed in _____.

5) The birds were moving art on a(n) _____ of sky and water and endless prairie.

6) A triangle _____ on an inverted triangle forms a six-pointed star.

7) She was proud to be a(n) _____ for reform in the government.

8) The doormat is made from _____ tires.

9) The walls of the old building are covered with _____.

10) The needs of today's children cannot be met by our old educational _____.

11) Variations of Koch's _____ question about consciousness have, of course, dogged philosophers for millennia.

12) The group has no _____ to any political party.

13) A collection is a revealing reflection of the taste _____ of the collector and of his aesthetic sensibility.

14) Blogging is the medium that lets us communicate with _____ people.

15) He's _____ to continue to improve services so that customers get a better deal in the future.

Part III Translation

1. Translate the following sentences into Chinese.

1) The T-shirt, just like the beanbag, spoke to one's emotional and sensual, rather than functional needs.

2) T-shirts were worn to street marches as a sign of peaceful protest, with their verbal and visual references acting as effective communication tools, bridging language and cultural barriers.

3) As a walking billboard, they provided unpaid advertising for companies such as Budweiser, Coca Cola, Disneyland and later, sporting companies such as Nike and Slazenger.

4) Ecological T-shirts were made of cotton that had been grown without the use of pesticides or from recycled materials.

5) It seems that the greater the commitment to a cause is, the more blatant the message becomes.

2. Translate the following sentences into English.

1) 标语衫不仅试图表达穿着者对各种社会问题的观点，而且让这些问题更加清晰可见。

2) 凯瑟琳·哈玛尼特（Katherine Hamnett）推出的哈玛尼特和平衫用经过认证的百分百有机棉制成，其胸前印有标语。

3) 2020 年东京奥运会火炬手穿着由回收塑料瓶材料制作的服装。

4) 去年春天，作为参观井冈山的纪念品，我买了这件 T 恤衫。

5) 穿着印有文化偶像的 T 恤衫能向世人展示你的人生理想和兴趣爱好。

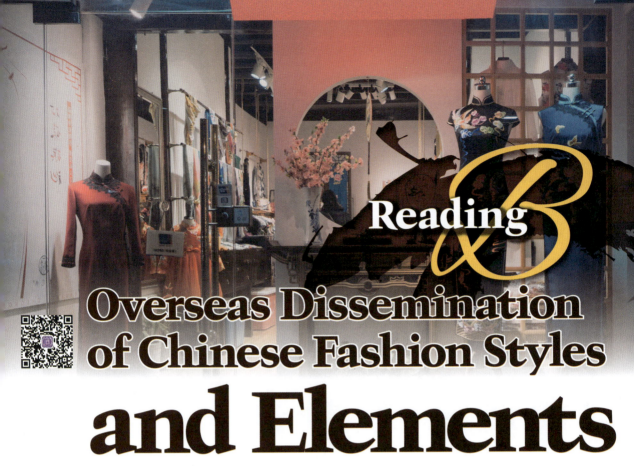

Reading B

Overseas Dissemination of Chinese Fashion Styles and Elements

dissemination *n.* 传播；散布

exaggeration *n.* 夸张；夸大

culminate *v.* 以……结束；告终

lacquerware *n.* 漆器

endeavourment *n.* 尽力；竭力

1 It is not an **exaggeration** to say that the dissemination of Chinese fashion styles and elements can be traced back to the ancient Silk Road which has been well-known as the most important trading route of ancient Chinese civilization for a long time. Later it **culminated** in the rococo period with many Chinese export goods such as silk, porcelain, **lacquerware** being exported into European countries. However, its flourishment starts from the late 20th century, which by no means can be separated from the **endeavourment** of Chinese-style fashion designers home and abroad besides the development of advanced technology, globalization of economy and cultural exchange between China and the world. Generally we think that the designers play their important roles in the overseas dissemination of Chinese fashion styles and elements by participating in the international fashion weeks, giving exhibitions abroad, tailoring for some big names and marketing their works with all kinds of advertisements. In this aspect Guo Pei and Ma Ke are always being regarded as the representatives

and on the top list of the Chinese-style fashion designers in China along with Mark Cheung[1], Liang Zi[2], Lawrence Xu[3], Jiang Qiong'er[4] and many others.

Guo Pei

2 Guo Pei is the first and only Chinese **couture** designer who was approved around the world and promoted the birth of China fashion. In her nearly 30 years of design career, she has been committed to constructing oriental aesthetics. Unsurprisingly, dragons remain one of the most important **motifs** in her collection. She released "Dragon's Story" collection in 2013 (Illustration 1; Illustration 2), in which she took dragons known for their power of **metamorphoses** as the source of inspiration. The five colors of the dragons—black, green, gold, silver and red—**allude** to the ancient Chinese philosophy of Five Elements and Yin/Yang. The designer also draws inspiration from ancient **iconography**: **whimsical** green dragons; mythical birds such as Rosefinch[5] (God of the South), three-legged Golden Bird[6] (symbolizing the Sun), and Phoenix (king of all birds); the basaltic pythons[7] (God of the North); and mighty unicorns. Guo summons all the **auspicious** animals from Eastern folklores and recreates them as symbols of the future, blurring the boundary between human sphere and mythological realm. In this magical world, one can fantasize the magical **carp** leaping across the Dragon Gate, while the fairy crane turns clouds and treads waves. Altogether, they **conjure up** a carefree picture of a spiritual paradise held in the highest regard in the Eastern culture.

couture *n.* 时装；时装设计制作

motif *n.* 装饰图案；主旨

metamorphosis *n.* 变形；变化；变质

allude *v.* 暗指；使人想起

iconography *n.* 图示法；象征手法

whimsical *adj.* 异想天开的；反复无常的；古怪的

auspicious *adj.* 有助于成功的；吉祥的；吉利的

carp *n.* 鲤鱼

conjure up 使浮现于脑海；使想起；使联想起

1 张肇达，中国当代知名时装设计师。
2 梁子，"天意"（TANGY）品牌首席设计师，被称作时装界的"环保大师"和"最中国的设计师"。
3 许建树，中国当代知名时装设计师。
4 蒋琼耳，中国当代新锐艺术品设计师。
5 朱雀，南方之神。
6 三足金乌，又称金乌、阳乌、太阳鸟、三足鸟等，是中国古代神话传说中驾驭日车的神鸟，为日中生有三足的乌鸦演化。
7 玄武，北方之神，出自《三辅黄图·未央宫》。

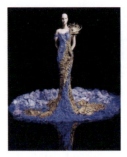 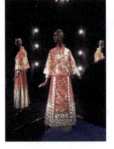 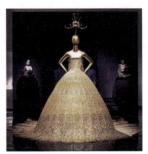

Illustration 1　　　　Illustration 2　　　　Illustration 3

3　In 2013, as the promoter of couture in China, Guo Pei was honored by Asian Couture Federation[1] as founding member designer and Asian Couturier Extraordinaire Member[2], plus the only Chinese designer of Singapore FIDé[3]. In recent years, Guo Pei was also invited by worldwide famous museums and exhibitions for showcasing her works. Her "Porcelain" collection and "Dajin" (Illustration 3) at the New York Metropolitan Museum, are part of the exhibition "China: Through the Looking Glass"[4] in 2015. Most of all, the big yellow gown wearing by superstar Rihanna[5] on the red carpet of Met Gala[6] makes Guo Pei in the spotlight and hits the headlines.

4　Relying on her talent in designing and enthusiasm of the fashion industry, the people who have the highest status, **prestige** and wealth become her most loyal customers. In 2015, her works impress the guests on the Fashion 4 Development's First Ladies Annual **Luncheon**[7] and she brought her legendary

prestige *n.* 威信；声望；魅力

luncheon *n.* 午饭；午餐

1　亚洲高级定制公会，也称"亚洲高级时装联盟"。
2　亚洲杰出高定设计师。
3　新加坡 FIDé 时装周。
4　"中国：镜花水月"，2015 年纽约大都会艺术博物馆年度大展的主题展。
5　蕾哈娜（1988— ），全名罗比恩·蕾哈娜·芬缇（Robyn Rihanna Fenty），在美国发展的巴巴多斯籍女歌手、演员、模特。
6　全称为 Metropolitan Museum of Art's Costume Institute in New York City，译为纽约大都会艺术博物馆慈善舞会，每年 5 月初举行。
7　F4D "第一夫人慈善午宴"，成立于 2011 年，响应"联合国千禧年发展目标"以及联合国秘书长潘基文发起的"每一个妇女每一个儿童"慈善项目号召，致力于大规模提升人民社会生活状态，目前已成为国际时尚产业以及公益组织群体中备受尊敬的标杆。

elegance to MAC¹ **cosmetic** by accompanying products with "Garden of Soul" couture dresses collection launched in New York.

cosmetic *n.* 化妆品

5 As a result of twenty years of experience and passion, Guo Pei brought her unique exhibition of thirty dresses, **authentic** works of art in the prestigious setting of the Musée des Arts Décoratifs², which reflects Guo Pei's deep desire to mark her presence in Paris during the French Couture Week, and expresses her strong will to settle in Paris in July 2015. Inspiringly, Guo Pei earned January show invitation officially announced by La Chambre Syndicale de la Haute Couture³. *Yellow is Forbidden*, an **eye-opening** documentary on Guo Pei, directed by talented Pietra Brettkelly⁴, has been submitted to Oscars as New Zealand's **submission** for the Best Foreign Language Film category. As a Chinese haute couturier with a showroom in Paris, a cover of American *Vogue*, a MAC collaboration and designs on display at the Met, Guo's influence on fashion and culture is enormous and barrier-breaking.

authentic *adj.* 真的；真正的；可靠的；可信的

eye-opening *adj.* 使人惊奇的；令人大开眼界的；使人恍然大悟的

submission *n.* 提交；呈递

Ma Ke

6 Ma Ke, as one of the most influential Chinese designers, was famous for starting China's first designer's brand Exception de Mixmind⁵ but quitted in 2006. She then founded Wuyong Studio, a social enterprise dedicated to the inheritance of and innovation on traditional folk handicrafts and to **rejuvenating** folk arts in modern society with original handmade items. She debuted "Wuyong / Luxurious Qing Pin"⁶ (Illustration 4) in Paris in 2008, becoming the first in China to present in Paris Haute Couture Week. Her works were exhibited in museums in

rejuvenate *v.* 使（公司、产品、市场等）恢复活力；使更有活力或效率

1 魅可，雅诗兰黛化妆品集团旗下的彩妆品牌，也是第一个非由兰黛夫人自创的品牌。
2 法国巴黎装饰艺术博物馆。
3 法国高级定制时装协会，成立于 1930 年。
4 皮耶特拉·布莱特凯莉，新西兰纪录片女导演，2018 年为中国知名时尚设计师郭培执导拍摄了时尚纪录片《明黄禁色》(*Yellow Is Forbidden*)。
5 "例外"，国产服装品牌，全称广州市例外服饰有限公司。1996 年由马可、毛继鸿创立。
6 "无用"之"奢侈的清贫"系列，2008 年 7 月由马可在巴黎小皇宫的露天公园中推出。

France, Britain, Netherlands, the U.S. and Japan. Another show named "Wuyong / the Earth" (Illustration 5) received the 11th Prince Claus Awards[1] in the Netherlands. *Wuyong*, the film featuring Ma Ke and her Paris presentation of "Wuyong / the Earth" directed by Golden Lion winner Jia Zhang-Ke[2], won Best Documentary Prize in the 64th Venice Film Festival.

Illustration 4 Illustration 5

unveil *v.* 为……揭幕；（首次）展示；介绍；推出

sustainability *n.* 可持续性

pavilion *n.* 阁；亭子

7 In September 2014, Wuyong Living Space[3], the first flagship store, was **unveiled** in Beijing, to showcase and sell handmade items (clothes, food and household items) that cover almost all aspects of life. The daily necessities made by Wuyong are natural and handmade with the aim to call for people's attention to simplicity, harmony with nature, environmental protection and **sustainability**. Since the founding of Wuyong, Ma Ke has become a comprehensive creator in cultural and art fields. She was awarded "World Outstanding Chinese Designer" by Hong Kong Design Center in 2009. In 2014, she was invited to design costumes for the new works of Lin Huaimin[4] (founder of Cloudgate). Ma Ke then presented her works at the 15th Venice Architecture Biennale[5] in China **Pavilion** and her exhibition on traditional handmade oiled-paper umbrellas

1 克劳斯亲王奖，每年颁发给特定领域中对文化和发展有杰出贡献的个人、团体、组织或者学术机构。

2 贾樟柯（1970— ），山西汾阳人，毕业于北京电影学院文学系，华语影视导演、编剧、制片人、演员、作家，上海大学温哥华电影学院院长。2007年，他拍摄的时尚纪录片《无用》在第64届威尼斯电影节上获得单元纪录片提名奖。

3 无用生活空间，由当代中国知名时尚设计师马可创立，位于北京市东城区美术馆后街，于2014年9月正式对外开放。

4 林怀民（1946— ），中国台湾人，舞蹈艺术家，1973年创办"云门舞集"。

5 第十五届威尼斯建筑双年展。

won DFA Grand Award[1] for Culture in 2016. In the same year, Wuyong was listed in China's top 10 fashion brands among the top 100 self-owned companies.

8 Besides the contribution of mainland fashion designers, the overseas dissemination of Chinese fashion styles and elements also **give credit to** some fashion designers born in Hong Kong or Taiwan, such as Shiatzy Chen[2], Eddie Lau[3], and some foreign Chinese such as Vivienne Tam[4], Anna Sui[5], Jimmy Choo[6], Vera Wang[7], Jason Wu[8] and so on. Among them the foreign Chinese fashion designers made their debut on the fashion stage and business in the 1980s. As one of the representatives, Vivienne Tam is an international designer known for her culture-bridging, east-meets-west **approach** to design. In 2017, she was presented with "China Fashion Award—International Designer of the Year 2017" on Mercedes-Benz China Fashion Week[9] in recognition of her contributions and achievements in promoting Chinese culture around the world. She was also honored by *Forbes*[10] magazine as one of the "25 Top Chinese Americans in Business" and *People* magazine as one of the "50 Most Beautiful People" in the world.

(1174 words)

(Adapted from Guopei website and wuyong website.)

give credit to 归功于；相信

approach *n.* （思考问题的）方式；方法；态度

1 "亚洲最具影响力设计奖"大奖，此奖由香港设计中心主办，自 2003 年首办以来，一直秉承其宗旨，从亚洲观点出发，表彰解决区内问题的优秀设计项目。
2 王陈彩霞（1978—　），中国台湾省彰化县人。知名时尚设计师，时尚品牌"夏姿·陈"的创始人之一。
3 刘培基（1951—　），中国香港著名时装 / 形象设计师。
4 谭燕玉（1957—　），生于广州，美国知名华裔时装设计师，1990 年在美国创立以自己名字命名的时尚品牌。
5 苏安娜（1955—　），美国知名华裔时装设计师，1980 年在美国创建了同名彩妆品牌。
6 周仰杰（1952—　），知名华裔鞋类设计师，创建了同名鞋类品牌。也是英国戴安娜王妃生前的御用鞋子设计师。
7 王薇薇（1949—　），美国知名华裔设计师，有婚纱女王之称。祖籍江苏徐州，生于纽约曼哈顿上东区。
8 吴季刚（1983—　），美国知名华裔设计师。
9 梅赛德斯—奔驰中国国际时装周。
10 美国福布斯公司商业杂志，总部设于纽约市，每两周发行一次，以金融、工业、投资和营销等主题的原创文章著称，同时也报道技术、通信、科学和法律等领域的内容。

Part I Understanding the Text

Task 1 Global Understanding

1. Read the text and decide whether the following sentences are true (T) or false (F).

() 1) The dissemination of Chinese fashion styles and elements can be dated back to the ancient Silk Road according to this passage.

() 2) The designer's brand Exception de Mixmind was founded by Ma Ke in 2006, but being quitted later.

() 3) *Yellow Is Forbidden*, an eye-opening documentary on Guo Pei was directed by Pietra Brettkelly, a woman director from Australia.

() 4) Guo Pei has been committed to celebrating Eastern aesthetics in her fashion design in the past 40 years according to the passage.

() 5) "Wuyong / Luxurious Qing Pin" presented in Paris Haute Couture Week in 2008 was Ma Ke's first appearance on the international fashion stage.

2. Match the main ideas to the paragraphs below.

Paragraph 1	A. Some fashion designers born in Hong Kong or Taiwan also make great contributions to the overseas dissemination of Chinese fashion styles and elements.
Paragraph 2	B. A general description of Guo Pei's oriental aesthetics.
Paragraph 7	C. Designers play important roles in the overseas dissemination of Chinese fashion styles and elements.
Paragraph 8	D. The founding of Wuyong by Ma Ke and its design philosophy.

Task 2 Detailed Understanding

1. Answer the following questions according to the text.

1) What does Guo Pei summon from Eastern folklores and recreate them as symbols of the future, blurring the boundary between human sphere and mythological realm?

2) What makes Guo Pei in the spotlight and hits the headlines in the Met Gala 2015 according to the passage?

3) What is Wuyong Studio's enterprise dedication founded by Ma Ke?

2. Discuss the following questions with your partner.

1) What can't the overseas dissemination of Chinese fashion styles and elements be separated from according to this passage?

2) Please make a summary of Guo Pei's design philosophy based on the information given in the passage.

3) Can you name any other foreign Chinese fashion designers actively appearing on the international fashion stage nowadays?

Part II Building Language

Task 1 Key Terms

The words or phrases below are related to overseas dissemination of Chinese fashion styles and elements. Discuss with your classmates and provide your understanding about each term in English.

1) Chinese fashion style: _____

2) The Silk Road: _____

3) Met Gala: _____

4) sustainability: _____

5) portfolio: _____

6) Haute Couture: _____

7) flagship: _____

8) *Yellow Is Forbidden*: _____

9) Wuyong Living Space: _____

10) Five Elements: _____

Task 2 Vocabulary

Choose the correct word or phrase from the box below to complete each of the following sentences. Change the form where necessary.

| auspicious | dissemination | sustainability | authentic | eye-opening |
| unveil | debut | whimsical | culminate | rejuvenate |

1) He started as an artist, making his _____ as a fashion designer in 1990.

2) Anything that stands in the way of the _____ of knowledge is a real problem.

3) They can do much to _____ old neighborhoods and keep the city from declining again.

4) Mary's excellent recording is a(n) _____ start to what promises to be a distinguished musical career.

5) That was a(n) _____ moment for me, an epiphany for me.

6) Their many years of research have finally _____ in a cure for the disease.

7) The memorial to those who had died in the war was _____ by the newly selected President.

8) In a discipline that celebrates bluntness, practicality and monomania, he was cursed with a(n)_____ imagination.

9) Would it be interesting, artistic, if all sincere, _____ feelings were honestly put on stage?

10) A plastic bag, environmentalists say, is made from petroleum products and, therefore, is an unfriendly choice for environmental _____.

Part III Translation

1. Translate the following sentences into Chinese.

1) Generally we think that the designers play their important roles in the overseas dissemination of Chinese fashion styles and elements by participating in the international fashion weeks, giving exhibitions abroad, tailoring for some big names and marketing their works with all kinds of advertisements.

2) In this magical world, one can fantasize the magical carp leaping across the Dragon Gate, while the fairy crane turns clouds and treads waves.

3) Most of all, the big yellow gown wearing by superstar Rihanna on the red carpet of Met Gala makes Guo Pei in the spotlight and hits the headlines.

4) The daily necessities made by Wuyong are natural and handmade with the aim to call for people's attention to simplicity, harmony with nature, environmental protection and sustainability.

5) Besides the contribution of mainland fashion designers, the overseas dissemination of Chinese fashion styles and elements also give credit to some fashion designers born in Hong Kong or Taiwan.

2. Translate the following sentences into English.

1) 中国时尚设计师和时尚领袖们对于中国风时尚风格的推广和传播发挥了积极作用。

2) "中国风时尚"这个短语本身就蕴含着中国时尚设计师振兴中国文化的热情和渴望。

3) 明星代言是诸多时尚营销和传播方式中最有效的方式之一。

4) 中国风时尚设计中常常有意使用一些传统的中国文化符号（如龙、荷花）、造型（如对襟、立领）、织物或者色彩。

5) 近年来工业和技术的进步让世界范围内的手工艺逐渐边缘化，不过，一些设计师正在努力挽救它们以避免其消亡。

Writing Skills

Writing an Essay

Part I Preparation

Task 1 Introduction

The essay is a staple of academic writing about a particular subject such as culture, politics, society etc., in which someone's ideas will be given. The purpose of an essay writing is to demonstrate or develop the ability to construct a coherent argument and employ critical thinking skills. It is mainly composed of three parts: introduction, body and conclusion. In the first part, a thesis statement should be given to let others know what you are writing about. Then, in the second part, the supporting statements and details should be listed to explain the topics one by one. In the concluding paragraph, restatement or final comment are required. A good essay does not need to be a long one. It needs to have good grammar, relevant points and good explanation. Add proverbs and good words if you can.

Task 2 Preparation Task

The following is an example of an essay. Fill in the blanks with appropriate words given in the box.

| from | of | first | to | in | is | as | or |

The ways in which fashion and clothing negotiate 1) _____ mediate identity and difference introduce a set of difficulties that have been referred to 2) _____ the "structure and agency" debate.

From one direction, the problem is to explain human agency in a way that does not ignore the role played in human activity by cultural and social structures; 3) _____ the other direction, the problem is to explain cultural and social structures in a way that does not reduce human agency to the simple reproduction 4) _____ those structures. 5) _____ terms of fashion and clothing the problem is to explain the construction and communication of individual identity through fashion and clothing agency in a way that does not reduce that agency or identity 6) _____ the predictable effect of existing structures or ignore the role of those structures entirely.

In the 7) _____ case, fashion is seen as the simple and predictable effect or reflection of social, cultural or economic structures; in the second case, fashion 8) _____ seen as entirely outside or beyond those social, cultural or economic structures.

Part II Reading Example

Back to Life or Reality?

How can fashion prepare us for today's ever-changing world? And when the seasons change, we may actually find we still want clothes that have the power to do what the best fashion has always done even if we have to wear them with a mask.

Lynn Yaeger has a three-point plan from new fall looks to what's already in your closet.

First, when you still want fashion, you want to look great on your virtual meeting or virtual date. The creator of knits, Glemaud, who is distinguished by a special stitch, argues that his knit dresses are for every wearer, which is why he decided to offer sizes from extra-small to 3X. "I am not designing in a bubble," he says. "This is about the world we live in now."

Second, could it be that all the walking, hiking, running, and biking we've been doing lately is the reason we have fallen in love again with flat boots? Maybe it's because we are spending so much of our downtime exploring our own neighborhoods and avoiding, when we can, taking public transportation, but the tough charm of a combat boot can make us feel literally more grounded.

Third, nowadays, a house is not just a home, it's also your office, your playroom, and the place where you entertain a select group of people. As we shift from going out to entertaining in our living rooms, it's not surprising that clothes affording a measure of warmth and comfort are so appealing. Bode says she is fascinated by the hidden narratives these textiles hold. "I want people to be excited to buy my clothes, and to pass them on," she says. "For me, that is what clothing is about."

Tips

- Make your essay persuasive and convincing.
- Develop your arguments for your thesis statement.
- Organize the supporting details and statements logically.
- Conclude your essay with concise and clear points.

Part III Task

Assume that you are the creative director of a Chinese-style fashion brand. Please write an essay about your design philosophy in about 150 words.

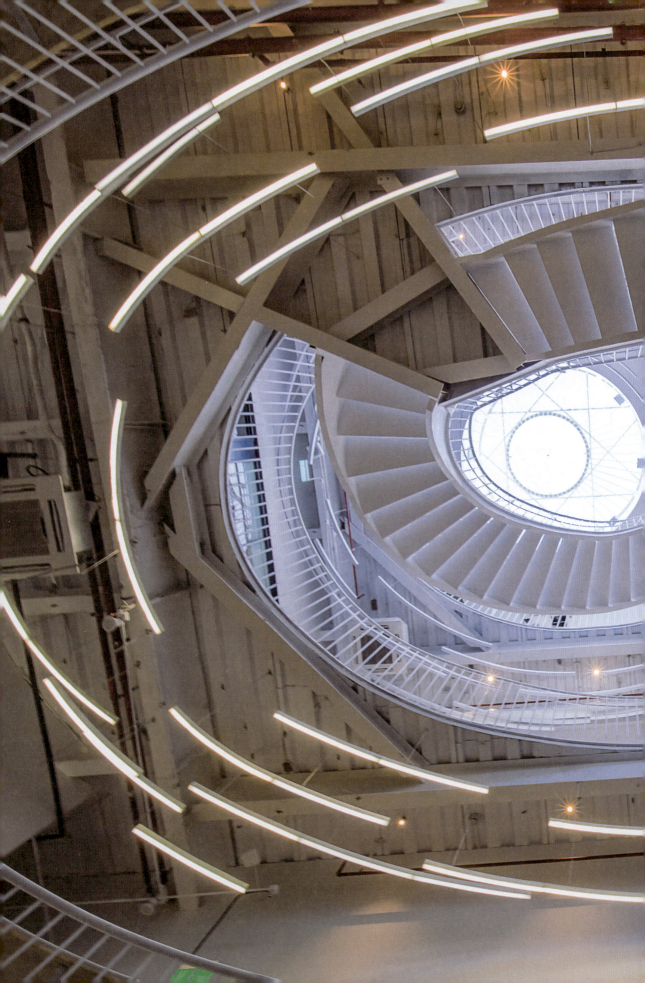

Learning Objectives

Students will be able to:

- understand the vocabulary of architecture and design;
- describe some of the architectural features;
- gain some knowledge about the famous American architect Frank Lloyd Wright through his works of architectural design;
- appreciate modern Chinese architecture;
- learn how to write a research proposal.

Unit 8

Architectural Works

Lead-In

Task 1 Exploring the Theme

Look at the pictures and try to identify American architect Frank Lloyd Wright's main works of design.

Fallingwater

Taliesin West

Solomon Museum (1)

Solomon Museum (2)

Tokyo Imperial Hotel

Task 2 Brainstorming

Answer the following questions. Discuss with your classmates and share your answers with the class.

1) Who is Frank Lloyd Wright?

2) What is Frank Lloyd Wright's key idea about architectural design?

Task 3 Building Vocabulary

Talk with your classmates, and try to describe the following words and phrases in English.

geometric simplicity	Tokyo Imperial Hotel	spirituality
harmony	Fallingwater	

Reading A

American Architect Frank Lloyd Wright[1] and His Key Works

architect *n.* 设计师

1 　As one of the most well-known and revered American **architects** of the 20th century, Frank Lloyd Wright conceived of more than 1,000 designs and executed around half of them over his nearly 70-year career. He had a sweeping vision, spanning places of worship; private homes and hotels; and museums, schools, and office spaces.

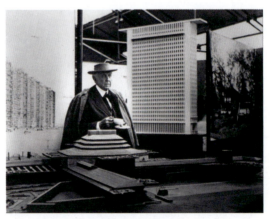

Frank Lloyd Wright

1　弗兰克·劳埃德·赖特（1867—1959），工艺美术运动（The Arts and Crafts Movement）美国派的主要代表人物，美国最伟大的建筑师之一，著名建筑学派"田园学派"（Prairie School）的代表人物。

2 Wright believed that there was a right way to design in the world, a natural architecture that served both beauty and **functionality** without sacrificing anything. He saw in houses, temples, and offices the potential not just for art, but for artistry—the ability to build dignified structures with an awareness and respect for their environments.

functionality *n.* 功能

3 **Underpinning** Wright's designs was his belief that Nature—with a capital "N"—was sacred. His design philosophy of "organic architecture" proposed that built environments should accommodate the natural world in service of a greater whole. Wright drew inspiration from Eastern art and architecture—particularly its emphasis on harmony, spirituality, and geometric simplicity. In 1957, he described the goal of an architect in almost missionary terms: "to help people understand how to make life more beautiful, the world a better one for living in, and to give reason, rhyme, and meaning to life."—In other words, a perfect unity of philosophy, materiality, and the natural world. Below, we share five key works from the celebrated architect.

underpin *v.* 巩固；加强

Prairie Houses

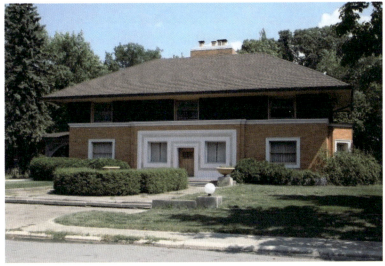

The Winslow House

4 The Prairie style defined Wright's early years as an architect—or, rather, Wright's early years defined the Prairie style. Around the turn of the 20th century, not long after starting his own architecture practice, Wright began crafting residences to fit the wide-open expanse of the Midwest.

5 A collection of these homes reside in the greater Chicago area. The Winslow House[1] (1893) in River Forest is cited as one of Wright's first explorations into the Prairie style, followed by the Arthur Heurtley House[2] (1902) in Oak Park and Frederick C. Robie House[3] (1910) in the city itself.

6 The Prairie School Movement came to exemplify a particularly American ethos, drawing inspiration from the Arts and Crafts Movement. Wright pioneered the trend towards open floor-plans, or "the destruction of the box". The architect once said: "Now why not let walls, ceilings, floors become seen as component parts of each other, their surfaces flowing into each other."

7 Wright's sprawling, low-slung Prairie houses featured overhanging eaves, spacious interiors, long window panels, and simple, repetitive geometric flourishes. An affinity for horizontal lines and unfinished materials rank among their most striking characteristics. Revolutionary at the time, Wright helped forge many of the architectural elements we take for granted today—leaving a lasting mark on aesthetic of the era.

Taliesin West[4]

8 In the mythology of Wright, Taliesin West looms large. Nestled into the arid landscape of Scottsdale, Arizona, this expansive complex that housed the living quarters, studio, and workshop was designed as a sister Taliesin home, a getaway

1 温斯洛住宅。
2 亚瑟·赫特利之家。
3 罗比住宅，位于美国芝加哥大学校园内。
4 西塔立耶森。

from the brutal Wisconsin winters where the first Taliesin stood. Though officially built in 1937, Taliesin West never really stopped evolving; Wright established it instead as a place to experiment, teaching apprentices his methods and styles. He is said to have used the property as a design incubator, changing plans as he went and making rough sketches on butcher paper.

incubator *n.* 孵化器；恒温器

butcher paper 牛皮纸

9 There is something satisfying about the way Taliesin West sits on the land, woven into the surrounding landscape. In a 1957 interview, Wright said: "I'd like to have architecture that belonged where you see it standing." He accomplished this through both design and engineering, including using warm earth tones and natural materials.

Tokyo Imperial Hotel[1]

10 Not long after Wright's Imperial Hotel officially opened in Tokyo, the city was hit by one of the most severe earthquakes of the century. The Great Kantō Earthquake of 1923 wreaked havoc on the area, yet somehow the hotel remained, sustaining only minor damage. Built with flexibility and stability in mind, the hotel's low center of gravity and so-called "floating base" kept the structure steady atop the turbulent earth.

wreak havoc 造成严重破坏

stability *n.* 稳定；稳定性

center of gravity 重心

turbulent *adj.* 动荡的；骚乱的

11 Wright drew inspiration from both Japanese and pre-Columbian architecture for the two structures he built on the 40-acre complex. The hotel entrance wrapped around a reflecting pool and leveraged a mix of traditional and industrial materials, including concrete and slabs of Oya stone—a soft local lava rock that was easy to carve. Wright imagined this design as a blending of East and West. As with all of his organic architecture, Wright saw the lines between context and construction as porous. The resulting design was decorative, a hybrid creation. In *Frank Lloyd Wright: Force of Nature*[2], Eric Peter Nash described the hotel as a "funhouse of unusual vantage points, idiosyncratic spaces, massive ornamentation,

concrete *n.* 混凝土

slab *n.* 石板

lava *n.* 岩浆；火山岩

porous *adj.* 多孔的；有孔的

decorative *adj.* 装饰性的；装饰的

idiosyncratic *adj.* 特质的；特殊的

1 东京帝国饭店。
2 《弗兰克·劳埃德·赖特：自然之力》(1996)，作者为埃里克·彼得·纳什。

Unit 8 Architectural Works

and picturesque views".

Fallingwater[1]

12 Perched over a waterfall, nestled amongst the trees, and partly obscured by leaves, Fallingwater (1936—1939) embodies Wright's famous proclamation that "no house should ever be on a hill", but rather "it should be of the hill, belonging to it". Integrated into the natural landscape of Bear Run, Pennsylvania, Fallingwater takes that mandate seriously.

proclamation *n.* 宣告；声明

mandate *n.* 命令；指令；授权；委托

country house 乡间别墅

13 Designed as the country house for department store owner Edgar Kaufmann Sr., Fallingwater stands today as one of Wright's most beloved works. The layered design of the dwelling creates a visceral effect. Its tall stone chimney is intersected by the horizontal terraces, extending out perpendicularly and hovering cantileveredly, over the river below. The rushing water is audible from within the house, and the terraces emerge like rock forms, constructed with native sandstone and mixed with the surrounding trees.

layered *adj.* 分层次的；有层次的

chimney *n.* 烟囱

terrace *n.* 平台；大型阳台

perpendicularly *adv.* 垂直地；直立地

hover *v.* 翱翔；盘旋

cantileveredly *adv.* 悬臂式地；悬吊式地

14 Wright did not camouflage the home within the landscape, but rather complemented it. The internal design also works to direct the attention outward, with low ceilings and small bedrooms directing visitors' attention to the expansive windows and the scenes beyond them.

camouflage *v.* 掩饰；隐藏；伪装

Solomon R. Guggenheim Museum[2]

15 Wright hated cities—at least how they were designed. The architect once described the New York City skyline as a "medieval atrocity". Yet he built a museum that has come to stand as one of the greatest symbols of the city itself.

skyline *n.* 天际线

atrocity *n.* （尤指战争中的）残暴行为

cylindrical *adj.* 圆柱形的

16 As a structure, the Guggenheim is sturdy, cylindrical, and imposing, spanning Fifth Avenue from East 88th to 89th Streets. Unlike many of Wright's other works, the museum does

1 流水别墅。
2 所罗门·R. 古根海姆博物馆。

not meld into its urban backdrop. The interior's fascinating and unusual layout features a central spiral that **unfurls** for visitors, who can experience the art from above or below, not only squarely in front of it.

unfurl *v.* 展开；呈现

17 It can be hard to leave a Guggenheim exhibit without discussing the building itself, like appreciating the binding of a book or an artful plate for food. It seems to circle back to Wright's greater ambition: realigning our attention to an active appreciation for our environment—both natural and built—and its immense impact on our experiences and the quality of our lives.

(1122 words)

(Adapted from Artsy website.)

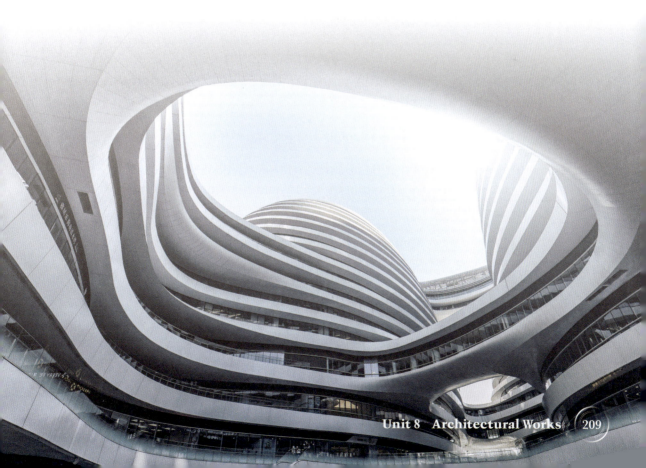

Part I Understanding the Text

Task 1 Global Understanding

1. Read the text and identify the main ideas.

1) What is the philosophy of Frank Lloyd Wright's architectural design?

2) Please write down some key information about Wright's design philosophy and works?

(1) _____

(2) _____

(3) _____

(4) _____

(5) _____

2. Read the text and decide whether the following statements are True (T) or False (F).

() 1) Frank Lloyd Wright is a famous 21st century architect.

() 2) Wright believed that there was a right way to design in the world, a natural architecture that served both beauty and functionality without sacrificing anything.

() 3) Wright drew inspiration from modern art and architecture—particularly its emphasis on harmony, spirituality, and geometric simplicity.

() 4) Wright doesn't like cities—at least how they were designed.

() 5) As Wright's other works, the Solomon R. Guggenheim museum melds into its urban backdrop.

Task 2 **Detailed Understanding**

1. **Read the text again and choose the best answer to each question below.**

 1) Which of the following is NOT Mr. Wright's favorite style?

 A. Prairie style.

 B. Fallingwater style.

 C. Architecture that emphasizes on harmony, spirituality, and geometric simplicity.

 D. Skyscrapers in the cities.

 2) Which of the following are the characters of Mr. Wright's Prairie style?

 A. Overhanging eaves. B. Spacious interiors.

 C. Long window panels. D. All of the above.

 3) Which is NOT one of the main characteristics of the architectural design of Fallingwater?

 A. Integration into the natural landscape.

 B. Fallingwater was originally designed as a department store.

 C. The internal design works to direct the attention outward.

 D. One purpose of the design is to direct visitors' attention to the expansive windows and the scenes beyond.

2. **Discuss the following questions with your partner.**

 1) How do you understand "the destruction of the box" in Paragraph 6?

 2) Do you know other works of Frank Lloyd Wright? How do they embody his philosophy of architecture?

 3) Who is your favorite architect? Can you introduce him or her in terms of life experience, philosophy of design, works, etc.?

Part II Building Language

Task 1 Key Terms

The words or phrases below are related to architecture. Discuss with your classmates and provide your understanding about each term in English.

1) flourish: _____

2) concrete: _____

3) eave: _____

4) window panel: _____

5) terrace: _____

6) interior: _____

7) slab: _____

8) center of gravity: _____

9) porous: _____

10) cylindrical: _____

Task 2 Vocabulary

Match the definitions on the right with the words on the left.

1) structure A decorated in a way that makes it attractive

2) stability B large and with plenty of space for people to move around in

3) decorative C everything you can see when you look across a large area of land

4) aesthetic D the quality or state of being steady and not changing or being disturbed in any way

5) chimney E made in an artistic way and beautiful to look at

6) functionality F the way in which the parts of sth. are connected together, arranged or organized

7) layered G a person who designs buildings

8) spacious H a pipe through which smoke goes up into the air

9) landscape I the range of functions that a thing can perform

10) architect J sth. that is layered is made or exists in layers

Part III Translation

1. Translate the following sentences into Chinese.

1) He saw in houses, temples, and offices the potential not just for art, but for artistry—the ability to build dignified structures with an awareness and respect for their environments.

2) His design philosophy of "organic architecture" proposed that built environments should accommodate the natural world in service of a greater whole.

3) The Prairie style defined Wright's early years as an architect—or, rather, Wright's early years defined the Prairie style.

4) The Prairie School Movement came to exemplify a particularly American ethos, drawing inspiration from the Arts and Crafts Movement. Wright pioneered the trend towards open floor-plans, or "the destruction of the box".

5) He is said to have used the property as a design incubator, changing plans as he went and making rough sketches on butcher paper.

2. Translate the following sentences into English.

1) 赖特先生开创了开放式的平面设计潮流。

2) 赖特先生从东方艺术和建筑学当中汲取灵感,尤其关注和谐的主题。

3) 所罗门博物馆本身已经成为这个城市一个伟大的象征了。

4) 由于在建造中考虑了灵活性和稳定性,东京帝国酒店的低重心以及所谓的"漂浮的地基"使之在1923年的大地震中幸存了下来。

5) 东方艺术和建筑强调天人合一的理念。

Reading B

Modern Chinese Architecture

Traditional Chinese Architecture

1 Chinese architecture is one of the major categories in the history of world architecture. For thousands of years, its unique feature of wooden construction system has become the essence of Chinese classical architectural culture, which has spread to East Asian countries such as Japan, South Korea and Vietnam.

2 Traditional architecture holds a special place in Chinese culture. **Masterpieces** of Chinese architecture, such as the Forbidden City[1], the Temple of Heaven[2], the Mogao Grottoes[3], are just a small part of China's cultural heritage. They are listed as UNESCO World Heritage

masterpiece *n.* 杰作

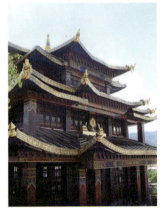

Traditional Chinese building

1 紫禁城。
2 天坛。
3 敦煌莫高窟。

Sites[1] not only because of their historical significance, but also because of their unique architecture.

3 Chinese architecture has a number of unique features: the elegance of all constructions and at the same time, their **monumentality**, the combination of different materials and colors, brightness and **sophistication** of internal and external **decoration**. The **interior design** of the building also has its own distinctive features. In addition to the walls, there are wooden pillars, decorated with **tiles** in the form of animals and plants. **Lacquered screens** were often used to separate one room from another. Architectural decoration strikes with the brightness of its colors. A traditional building in black and white or **grisaille** can rarely be seen in China.

4 From **intricate carvings**, strong fort-like walls, pictorial bronze walls to a list of other styles, traditional Chinese architecture developed and integrated mechanism that would safeguard their buildings from foreign attacks and, in the meantime, look beautiful and sacred. For example, one of the main features of Chinese-style buildings is a **concave roof**. No matter where you are, if you see the concave roof of a building, you immediately realize that it was built in Chinese style. These are some of the key elements that defined traditionalism in Chinese architecture.

monumentality n. 纪念性

sophistication n. 复杂巧妙；高水平

decoration n. 装饰

interior design 内部设计

tile n. 瓦

lacquered screen 漆面屏风

grisaille n. 纯灰色画

intricate adj. 错综复杂的

carving n. 雕刻

concave roof 凹形屋顶

Evolution of Modern Chinese Architecture

5 China has long since evolved from its **pagoda** structures, wooden columns, and colorful **décor**. These were the symbols of traditional Chinese architecture and it has existed for centuries under different dynasties. However, the modern age has allowed cultures to **intermingle** and ground-breaking ideas to generate. This has impacted and altered Chinese architecture and art extensively.

pagoda n. 塔；塔形建筑物

décor n. 装饰风格

intermingle v. 使（人、思想、色彩等）混合

1 联合国教科文组织世界遗产地。

6 Ever since the end of the Opium War[1], the British gained access to China through several international ports. They began their lives in China as merchants and traded goods between the two countries, making them a large part of China's economy and culture. It was during this time that Western ideas were shared with Chinese contemporaries, creating a newly opened **faucet** for modern creativity to flow through. After the Opium War, Chinese architects began incorporating more Western architectural characteristics into their styles and designs.

faucet *n.* 龙头；旋塞

7 Yet, the blend of Western and Eastern ideas took a few years to **materialize** in the form of art and architecture. Most Chinese buildings already displayed loyalty towards traditional Chinese architectural styles and very few people envisioned a modernistic China. This continued until the 20th century when the People's Republic of China came into being.

materialize *v.* 实现；发生；成为现实

8 Modern architecture incorporates **sleek** and **streamlined** concepts that are more appealing visually. After the establishment of the PRC, the consequent economic reforms created a demand for modern buildings. This is when the idea of westernized Chinese architecture was gradually transformed into reality.

sleek *adj.* 时尚的；光滑的

streamlined *adj.* 流线型的

9 Currently, China draws the focus of the world on modern and advanced architectural structures. There are numerous projects underway which aim to **fortify** China's urban environment while also providing trendy and comfortable spaces for international travel and investment.

fortify *v.* 筑防御工事；增强

10 The speed with which China has transformed its traditional architectural principles into contemporary and modern environments is entirely fascinating, as one Italian architect comments, "China is today a place to be… China is giving great architects amazing opportunities at this moment through financial power, a very fast decision process and a physically fast construction. In the time they build a tower there, we build

1 鸦片战争。

a little house."

Design of Contemporary Chinese Architecture

11 The design of Chinese architecture has also come to adopt more Western applications, such as incorporating restaurants, bars, clubs, shops, and businesses into one building. This multi-use of buildings is very different from traditional Chinese style, which had separate and defined uses for each building. The Water Cube[1] was designed with this **mindset**, taking on an identity that is more than just a place to recreate, but also a place to shop, eat, and socialize.

mindset *n.* 观念模式；思维倾向

12 There is also a lot of **verticality** in modern Chinese design. The reason behind the design of such towering structures is the country's massive population. China is the country with the largest population in the world, and cities like Hong Kong and Shanghai have extremely high density in terms of the number of people per square foot. With a booming population and limited space, architects are forced to build upward but not outward, creating powerful skylines and cityscapes.

verticality *n.* 垂直

13 While the designs of many modern Chinese structures look effortless and almost organic in form, they are more **meticulously** planned and engineered than ever, with intricate geometries and layers.

meticulously *adv.* 小心翼翼地；细致地

Defining Styles of Modern Chinese Architecture

14 Unlike the traditional emphasis on colors, carvings, and intricacies, modern Chinese architecture focuses on a limited palette in styles and techniques. They are usually composed of futuristic buildings with a greater focus on depth and height. **Symmetry** plays a key position in the design of all new buildings, where places such as the Galaxy Soho[2] or the Grand

symmetry *n.* 对称；相仿

1 水立方。
2 银河 SOHO。

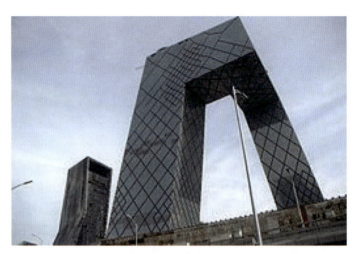

CCTV Headquarters

Hyatt Hotel[1] exemplify the use of the symmetrical composition.

15 Furthermore, these modern designs are often very clean. They include geometrical shapes and lines which do not mingle together in a complex manner. Most of the buildings and structures use only one or two types of shapes to design the entire property. This develops either a playful or a sophisticated look within the whole structure.

16 Most of the buildings use glass windows largely in order to create a polished Western look. It draws in more light inside and offers a meditative and natural quality indoors.

17 Modern Chinese architecture takes on a very sleek and futuristic style. Buildings appear more open-concept and streamlined. Open concept simply means that the floor plan and overall design make use of large open spaces (rather than several small, sectioned-off spaces). The National Grand Theater of China[2] in Beijing (nicknamed The Giant Egg) is a prime specimen of modern architecture in China. It has a seamless curvilinear design and peaceful aesthetic while still functioning as an event space.

18 Another great example of this style is the CCTV (Central

1 君悦大酒店。
2 中国国家大剧院。

China Television) Headquarters, which was completed just in time for the broadcasting of the 2008 Summer Olympics in Beijing. The style of the building showcases clean lines and innovative expression of form. Six horizontal and vertical structures link together to create a square loop, and an expanse of glass windows on every **façade** reflects the backdrop of the city.

façade *n.* （正）面；（表）面

19 The styling of modern Chinese architecture can be very playful with shape and expression. A great precedent of this playful yet modern look is the National Aquatics Center, also known as the Water Cube, in Beijing. This building was constructed for use in the 2008 Olympics, but now functions as a public aquatics center, spa and shopping center, not just an architectural statement for fun. The Water Cube, as its name implies, is very modular in shape. The outside surfaces are covered with bubble shapes. It also changes color in the evenings and becomes a lively gathering space for visitors.

(1234 words)

(From study website.)

Part I Understanding the Text

Task 1 Global Understanding

1. Read the text and identify the main ideas.

1) What are some of the main characteristics of traditional Chinese architecture?

2) What are some of the main characteristics of modern Chinese architecture?

2. Can you write down some key information about modern Chinese architecture?

3. Read the text and decide whether the following statements are True (T) or False (F).

() 1) Modern architecture incorporates sleek and streamlined concepts that are more appealing visually.

() 2) The multi-use of buildings is very common in traditional Chinese architecture.

() 3) The booming population and limited space usually forced architects to build tall buildings, thus creating powerful skylines and cityscapes.

() 4) Modern architectures tend to showcase clean lines and innovative expression of form, such as the CCTV Headquarters.

() 5) Masterpieces of Chinese architecture, such as the Forbidden City and the Temple of Heaven, are typical examples of Chinese modern architecture.

Task 2 Detailed Understanding

1. Read the text again and choose the best answer to each question below.

1) Which of the following is NOT the unique feature of traditional Chinese architecture?

 A. Distinctive interior design of the building.

 B. Being futuristic.

 C. The combination of different materials and colors, brightness.

 D. Sophistication of internal and external decoration.

2) Which of the following is NOT a good example of modern Chinese architecture?

 A. CCTV Headquarters.　　　　B. The Giant Egg.

 C. The Water Cube.　　　　　D. The Forbidden City.

3) Which of the following is/are the feature(s) of modern architecture and design?

 A. Futuristic buildings with a greater focus on depth and height.

 B. Buildings that use glass windows largely to create a polished Western look.

 C. Buildings that tend to have multiple functionalities.

 D. All of the above.

2. Discuss the following questions with your partner.

1) Can you raise more examples of modern Chinese architecture? Try to analyze their features.

2) What can you learn from the evolution of modern Chinese architecture?

3) What are the differences and similarities between modern Chinese architecture and the traditional one?

Part II Building Language

Task 1 Key Terms

The words or phrases on the left are related to architecture. Match each of them with its appropriate meaning on the right.

1) streamlined A removing parts to create a desired shape

2) verticality B a building that is used for religious purposes; usually a pyramidal tower with an upward curving roof

3) construction C the style in which the inside of a building is decorated

4) carving D having a shape that allows it to move quickly or efficiently through air or water

5) concave roof E the exact match in size and shape between two halves, parts or sides of sth.

6) lacquered screen F position at right angles to the horizon

7) pagoda G the process or method of building or making sth., especially roads, buildings, bridges, etc.

8) décor H a roof rounded inward like the inside of a bowl

9) symmetry I the front of a building

10) façade J a piece of furniture used in traditional Chinese buildings to keep out the wind and the line of sight

Task 2 Vocabulary

Replace the underlined parts in the following sentences with the expressions below that best keep the original meaning.

1) However, the modern age has allowed cultures to intermingle and <u>ground-breaking</u> ideas to generate.

 A. underlying　　B. original　　C. prior　　D. innovative

2) Modern architecture <u>incorporates</u> sleek and streamlined concepts that are more appealing visually.

 A. involves　　B. excludes　　C. collaborates　　D. consolidates

3) There are <u>numerous</u> projects underway which aim to fortify China's urban environment while also providing trendy and comfortable spaces for international travel and investment.

 A. less　　B. many　　C. countable　　D. little

4) With a <u>booming</u> population and limited space, architects are forced to build upward.

 A. increasing　　B. reducing　　C. flourishing　　D. prosperous

5) The designs of many modern Chinese structures are more meticulously planned and engineered than ever, with <u>intricate</u> geometries and layers.

 A. difficult　　B. involved　　C. sophisticated　　D. simple

6) They are usually <u>composed</u> of futuristic buildings with a greater focus on depth and height.

 A. brought of　　B. made up of　　C. used of　　D. change of

7) They include geometrical shapes and lines which do not <u>mingle</u> together in a complex manner.

 A. associate　　B. mix　　C. sort　　D. merge

8) A great <u>precedent</u> of this playful yet modern look is the National Aquatics Center, also known as the Water Cube, in Beijing.

 A. sample　　B. example　　C. pattern　　D. specimen

Part III Translation

1. Translate the following sentences into Chinese.

1) Chinese architecture is one of the major categories in the history of world architecture. For thousands of years, its unique feature of wooden construction system has become the essence of Chinese classical architectural culture, which has spread to east Asian countries such as Japan, South Korea and Vietnam.

2) With a booming population and limited space, architects are forced to build upward but not outward, creating powerful skylines and cityscapes.

3) While the designs of many modern Chinese structures look effortless and almost organic in form, they are more meticulously planned and engineered than ever, with intricate geometries and layers.

4) Unlike the traditional emphasis on colors, carvings, and intricacies, modern Chinese architecture focuses on a limited palette in styles and techniques.

5) Open concept simply means that the floor plan and overall design make use of large open spaces (rather than several small, sectioned-off spaces).

2. Translate the following sentences into English.

1) 水立方不仅是一个充满趣味的地标建筑，还兼具实用性和观赏价值。

2) 充分利用对称艺术是现代中国建筑的重要特点之一。

3) 中国的经济实力以及决策和建造速度给了众多建筑师极好的机会。

4) 中国有大量工程项目正在进行中，旨在优化城市环境，同时为国际旅游和外商投资提供新潮、舒适的空间。

5) 从传统建筑理念到当下现代的环境，中国的转型速度属实惊人。

Writing a Research Proposal

Part I Preparation

Task 1 Introduction

Your research proposal is the most critical component of your research degree application. It will form the basis for discussion at your interview, and if your application is successful, your proposal will also be used as the starting point for the registration process. The proposal should describe your area of interest, field of study and the particular focus of your intended work and should include a rationale to show why this is a valuable service design project for you to undertake. It should include an overview of the methodology, how you intend to go about producing the project, and an indication of what the outcomes could possibly be (but not a fully developed outcome).

Task 2 Preparation Task

The following is part of an example of a research proposal. Fill in the blanks with appropriate words given in the box.

> plan apply offer related design integrate

In order to solve the problem of queuing in amusement parks, we can:

1) _____ new queuing space for different groups of people; 2) _____ different solutions to corresponding stages of waiting; 3) _____ universal interactive devices in accordance with performance of people in line; 4) _____ existing solutions into a complete service system. If the project goes well, I expect to further 5) _____ it in any scene 6) _____ to queuing.

Part II Reading Example

1. Introduction

Queuing up is a boring, lengthy but inevitable process while playing in modern theme parks. Researches show that waiting time is directly related to customer satisfaction for they are easy to feel anxious and impatient during a long wait. Therefore, my topic is about how to improve people's queuing experience at amusement parks.

2. Project Overview

Some attempts have been made to reduce the unpleasant experience of waiting in the theme parks, including:

- Let visitors know how long they will wait by posting wait-time labels outside recreation facilities.
- Reduce waiting time. For example, queuing systems like "Six Flags' Q-Bot" and "Disney's Fast Pass" have been put into use.
- Offer customers something to play, for example providing interactive devices and dress shows.

However, with the view of queuing psychology, queuing is a dynamic process that people's mental status and psychological demands change during the waiting time, and also, visitors in the theme part are of different age groups. The current solution cannot completely solve the problem of queuing. Besides, costs of production, management and maintenance need to be taken into account by the leaders and staff of the parks.

As a result, I propose several questions to clarify the goal of my potential project:

- How to design based on the different needs in stages of waiting in order to improve the queuing experience?
- How to improve the queuing experience service and apply it to varieties of groups?
- How to improve the customers' queuing experience while taking stakeholders into consideration to ensure that the entire system is effective and beneficial?

3. Methodology

First, field research will be used to observe people in line at the theme parks. Second, through in-depth interviews with different groups of people, the most troublesome problems and psychological changes of them in the whole queuing process can be discovered. Third, interviews with administrative staff of parks will then be arranged to

better understand what is being done to improve the queuing experience and what they hope to achieve. After a number of first-hand researches, analysis will be needed.

4. Conclusion

All in all, this proposal explains my interest in improving queuing experience. In fact, this is a systematic and complex issue. How to make this service system as effective as possible for everyone, and even how to draw an analogy from the queuing experience in amusement parks to put forward a more universal solution which can be applied in any queuing scene to promote user experience, is a relatively challenging problem.

Tips

- Your proposal should be concise and descriptive.
- Make use of subheadings to bring order and coherence to your proposal.
- The Methodology section should contain sufficient information for the reader to determine whether the methodology is sound.
- It is important to convince your reader of the potential impact of your proposed research.

Part III Task

Assume that you're going to write a research proposal to apply for a research degree abroad. Please write the research proposal in about 300 words.